DAILY BREAD

"Old people, both economically and spiritually, know all about finitude, about conservation, about making do and making demands, about gratitude. 'Give us this day our daily bread,' they say, to their God, to their children, to the Social Security Administration. Give us what we need, the irreducible minimum, that which confers dignity."

—Marc Kaminsky

DAILY BREAD

Poems by Marc Kaminsky

Photographs by Leon Supraner

UNIVERSITY OF ILLINOIS PRESS

Urbana Chicago London

Grateful acknowledgment is made to the editors of the magazines, anthologies, and newspapers in which many of these poems previously appeared:
Sun: "Dancing Bear," "Building the Wall," "The Embrace"; *The Little Magazine:* "Hands," "Song," "The West Side Senior Center" (retitled "The Old Women"); *WBAI Folio:* "Hard Times"; *Response:* "Shiva," "First-born Son," "An Old Woman Takes Leave of Her Sleeping Husband" (early version of "For Her Dying Husband"), "Medium," "Rummage," "The Persisting Rage," "Reverie," "Remembering Lutsky," "My Mother's Shoes"; *Broadway Boogie:* "Emigration from Childhood" (early version of "A Young Man in America"); *National Jewish Monthly:* "A Fable"; *Handbook:* "Erev Shabbos," "Pig Market," "A Man at Work"; *Choomia:* "Among the Americans," "Lives of the Poets"; *Catalyst:* "Looking into First-floor Windows"; *Footprint Magazine:* "Golus Jews," "Many Ghettos," "Game of Checkers"; *Journal of Gerontological Social Work:* "Hitting Rock Bottom," "The Ending"; *Jewish Daily Forward:* "Pig Market"; *New York Times:* "Dancing Bear," "Building the Wall"; The Sarabande Press: "Rummage" (broadside); *Voices within the Ark: The Modern Jewish Poets* (Avon): "Erev Shabbos," "Reverie," "Remembering Lutsky," "My Mother's Shoes." Several poems appeared in three of the poet's previous books: "Dancing," in *What's Inside You It Shines Out Of You* (Horizon); "March Poem" (retitled "Not Spring, Not Winter"), in *A New House* (Inwood/Horizon); and "Embrace" and "Milk," in *A Table with People* (Sun Press).

Thanks to David Soyer and Bernard Warach, of the Jewish Association for Services for the Aged, and to Rick Moody and Rose Dobrof, of the Brookdale Center on Aging, for their encouragement during the early phase of our collaboration.

—M.K. & L.S.

LIBRARY OF CONGRESS CATALOGING IN PUBLICATION DATA

Kaminsky, Marc, 1943–
Daily bread.
I. Supraner, Leon, 1925– . II. Title.
PS3561.A418D3 811'.54 82–7057
ISBN 0–252–01000–0 AACR2

For my Robyn,
who believes
 —L.S.

For Bill McClellan & Yvette Mintzer
 —M.K.

CONTENTS

Foreword viii

I. Grandparents

Dancing Bear 3
Hands 5
For Her Dying Husband 7
Underground 11
Shiva 17
First-born Son 19
Erev Shabbos 23
Medium 25
Pig Market 29
Many Ghettos 33
Lives of the Poets 35
Remembering Lutsky 39
Rummage 41
Golus Jews 43
Milk 45

II. Portraits

Waking 51
Hard Times 53
Dancing 55
Flying 57
Reverie 59
Words That Are Barely Spoken 61
A Winter Vacation 63
Estranged 67
Sales Lady 71
Not Spring, Not Winter 73
What the Psychiatrist Said 75
A Game of Checkers 77
The Ending 79
The Embrace 83
A Fable 89

III. Complaints

Who Are You? What Do You Do? 93
A Young Man in America 97
The Common Routine 101
Hitting Rock Bottom 103
The Old Women 107
Building the Wall 111
My Mother's Shoes 113
Looking into First-floor Windows 115
Family Circus 117
The Persisting Rage 121
Among the Americans 127
Finding Myself
 in the Presence of the Queen 131
Insomnia 133
Song 137
Hungry Ghost 139
A Man at Work 145

Glossary 147

FOREWORD

What a pleasure it was for me to ''experience'' *Daily Bread,* this collaboration of poet Marc Kaminsky and photographer Leon Supraner. I say ''experience'' because the poems and photographs evoke for us a life that has passed: a special world, that unique pocket of the Lower East Side, representing the triumph of a people from another century, another place. ''You know what I am waiting for? Nothing miraculous. Only a letter with 18 rubles, plus a steamship ticket to America.'' These poems and photographs include the ''memories of generations of fugitives, all landing at once in America.''

I have studied aging from various perspectives—in the clinic, in the community, in the laboratory—examining biological, psychological, and social variables. I have been trying to understand what aging of the mind, body, and spirit is all about. When I became a gerontologist and began to listen to older persons, I could not believe what I had read about them in psychiatric textbooks—that their reminiscences were of little value, for example. Reminiscences were interpreted as reflections of carelessness, wandering of mind, garrulity, idle nostalgia, even markers of pathology. I came to a different conclusion, postulating that reminiscence in older persons is normal, potentially constructive and spurred by the inner realization of life's finitude.

My own studies of healthy, older persons living in the community were conducted between 1955 and 1966 and included many Jewish immigrants from the shtetls of Eastern Europe. These immigrants helped me to recognize and understand the ''life review'' as they reminisced about their childhoods and their long lives. The poems and pictures of *Daily Bread* are life reviews, providing insightful sketches of character and place as well as invaluable information

about a historic period. And they tell of New York City, which only became a world metropolis following the arrival of millions of immigrants.

Kaminsky's poems re-open the doors of sweatshops of the garment industry, as well as invite us into contemporary homes for the aged. A few of the poems, such as "A Game of Checkers" and "Who Are You? What Do You Do?" were written in response to the photographs. More commonly, Supraner found visual equivalents to Kaminsky's images. These poems and photographs search out the whole of life, the cycle of life, the end of life—without sentimentality or artificiality.

Given the realities of ageism, the profound devaluation of age in contemporary life, it is brave to publish a book of elderly faces with poems about growing old. But it will not be many years before our culture, arts, and sciences will be markedly influenced by the increasing proportion and absolute number of older persons. This is the first century in which a newborn infant can be expected to live out a full life. This unprecedented fact makes it the century of old age.

The artists who have brought us such fine works as the movie *Umberto D,* the play *The Gin Game,* and now the volume *Daily Bread* will be followed by an increasing number of others who will help us appreciate and understand this remarkably expanded last stage of life.

Robert N. Butler, M.D.
Director, National Institute on Aging

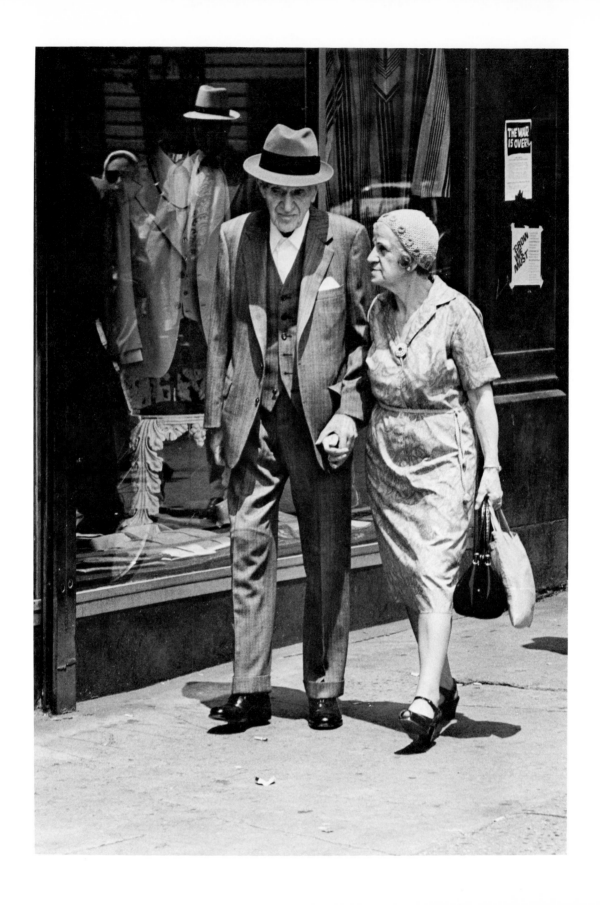

I. GRANDPARENTS

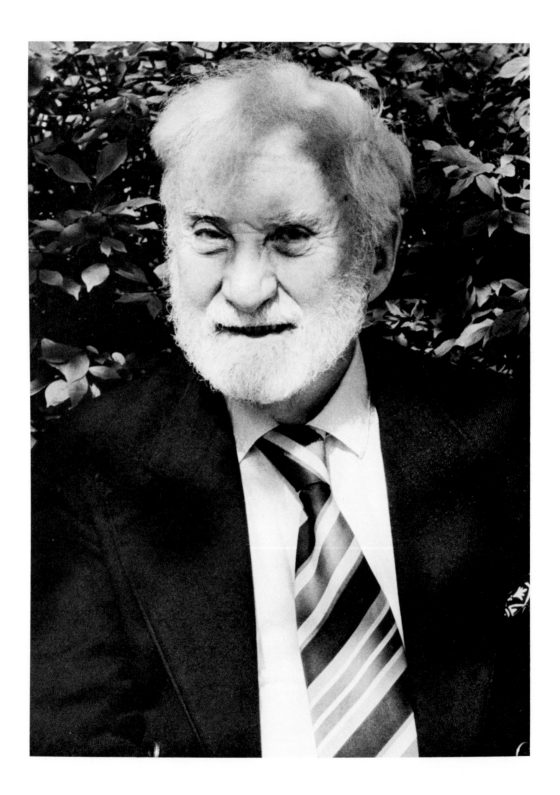

DANCING BEAR

My father, when his sons and daughters
visit his table, bringing freshly picked
husbands and wives, sits at the head
like a man who's come into his place
and is drunk with his triumph. He jumps
up and pulls each one of us to him
into a great wet bear hug, and cries:
Bring me grandchildren! Go home
and get me some grandchildren!
Quick! I want them
to get me greatgrandchildren before I die.
And my mother, trying to make him
act like a grown-up, cannot,
during the whole time he dances around us,
get him back on the leash.

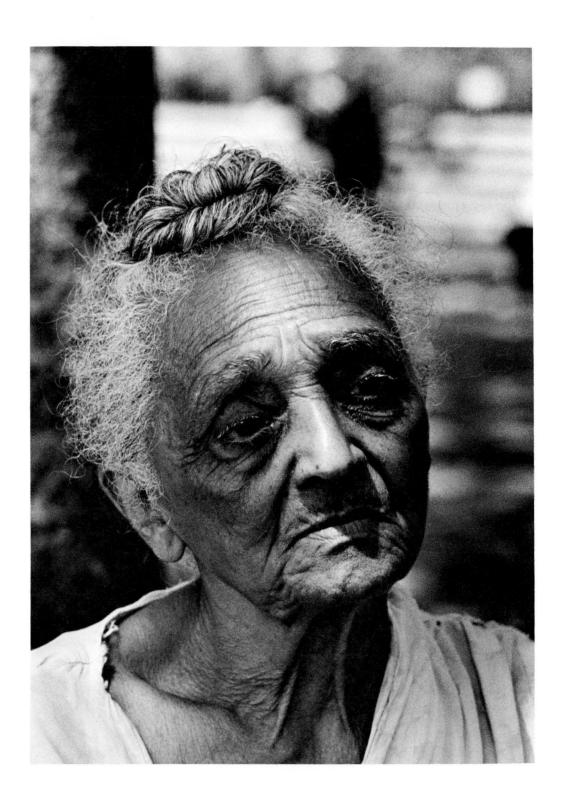

HANDS

for Bluma Kaminsky

My grandmother, her 84th summer half gone,
sits in an old terrace of the sun,
two of her wrist bones broken,
a blind sister shambling about the house
like a bat, waiting to die or be fed,
and though everyone she touched, her husband
or her sons, or the wives of her sons, or their children
are dead, or worse than dead—indifferent
to an old woman with a bandaged hand;
and though she fought the Angel of Death
five decades, first as a young mother
and last as an old wife, and lost each time,
she converses with a power which continues to mend,
her wealth of memories intact.

Touching their bodies lightly, as after a bath,
or convulsion of love or of childbirth,
or an agony of disease that is almost done
and, except for her sparing presence, the only medicine;
touching them lightly, son and dear son
and a life's companion, her mind calls on them all,
and all might remember, were they alive or more generous,
the ministry of her fingers on wounded flesh
when she, like a maker of the song that heals,
picked out the right notes and moved swiftly away.
Now in the wide quietness of the sun
what she has given and what she once was,
those warring melodies, return once again,
and the bitter hands mend.

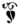

FOR HER DYING HUSBAND

What are you dreaming there?
How you used to sleep
curled around me?

And your hand would drum
the figures of a new poem
on my belly or back

I would awake
and say, So? It scans?
That woke you up
and you got it all down

At your desk, and later
in bed
I called you
my craftsman, my crumpler
of sheets

Now what
are you tapping there
on the pillow?

Are you knocking
to be let in under the ice
and snow
where our children lie?

Are you
still reaching over for me?

Oh Yeshieh
I'll get on, you'll see

There's nothing left
to do in the world

You can't hold a pen
or a spoon
and your eyes won't stay open

No more dying

I wish you everything
a wife's soul
can wish for a husband

May you find a place
where no memories
of the dead
follow
and continue to speak

where you have no care
for your surviving
son

no longing, no Yiddish, no union
no classes of little children
to teach, no soul-crushing debts

no toast and applesauce
with me
when the moon lays a silver cloth
on the bed and the table

no hay fever no Parkinson's
disease no summer day
boxed in at the window no
socialism no writing

no dreams no cities shining
in the head no word
to bring out of the darkness

nothing to get across
to the torn
distracted flesh of the living

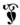

UNDERGROUND

for Yeshieh Kaminsky

1
As a boy, supple
and six-witted, he learned how
to crowd his body in
a crack
in the earth
and let the horsemen eat the wind, riding by
overhead

Zhid! zhid! he heard them
biting into the sky
with their whips, with their long black *nagaikas*
 Zhid! zhid!
cracking open the air
and foraging
in the fields above him

 It took a long time
 till that cry
 stopped
 in me

 —Little mouse
little Jew, cringing
in the darkness he hears
nothing
 but the terribly galloping
blood, his own heart

in hiding

2 Similarly, he happened to
disappear early one morning before the blood
red river
could come down
to the locked hut where he was
closely guarded, and his guards were
waiting for the light

for the crack
of dawn

by which they were going to lead him out
of six layers of skin
and out of his bones and his good two eyes
and out of his mouth
and his mind
and out of his cares for the poor

who were due to inherit the earth
after how many years of perdition

and out of his belief
he had planted a bomb in the mud
under the ballroom
where the Russian generals were dancing
quadrilles with the Polish gentry
while he crawled
three times under the elevated dance floor
to rekindle the wet fuse
and the only upshot of this
infinitesimal piece of the Revolution of 1905
was a few splintered floorboards

for which he was going to die

Zhid! zhid! enjoy for the last time
the pleasure of your morning
piss!

For the sun was already shaking
a few Russian tresses
over the edge of Poland
and they were about to take him
face to face with the Czar's
firing squad
 in a field of stubble

 Go on! Piss
 everything out, or
 you'll have to hold it in
 till the end of time
 Take aim now!

And they rushed in to get him

He, meanwhile, was stealing away
through the false dawn
of 1905
through factory towns like garrisons
and land masses
that were forever repeating the same
hay and potato
field under the same
lowering sky
and the black tree
that rushed into view

flickered on
and on in the window frame
hypnotically repeating
 that he and his friends
 could do nothing
 on earth
 change nothing
and his smallness
and the futility
of all merely human effort
were plain before him—
he nearly jumped from the train

but the moment passed

And he rode on
invisibly to soldiers and gendarmes, he was passing
through all the borders
between Poltava and Rotterdam
without a name and a face
and a recognizable body
he was being spirited
through a whole continent of "objective conditions"
by the underground railroad

3 I remember once in the early sixties before
I or anyone knew anything
about the bombing
of North Vietnam and the fire
had not yet come
to Chicago, to Watts, to New York
it was before
my world cracked
open, and I was riding the D train
to an amusement park in Coney Island

and just as we came up for air and started over
the endless cemeteries of Brooklyn
my father pointed
to the place where he was still new
in his grave, and muttered

> Is this what he came for?
> to end up *under*
> *a subway?* even here
> he doesn't get any peace and quiet!

And I heard thunder
of hooves
 over his head

remembering his stories

and suddenly I became afraid
that the dead
 still have ears and memories
and he was reliving the terrible days
when he had to be buried.

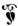

SHIVA

for Alter Schwartzman

Frost on the windows
telephone off the hook
it is almost January
my house is dark
and I am naked under the white sheets

My house is dark
and my grandfather is dead
except for the student lamp near my bed
It is a simple Besarabian piece
made in another century
out of brass
Its green shade of hand-blown glass
is a refuge

There is no comfort
beyond the small circle of light that it casts
and I am happiest here
with an old book
that falls from my hands
and I dream that my passing life is past
and the trampling feet and the broken cries
no longer mount five stories
to reach me
where I lie
so perfectly quiet
in my little pocket of winter

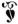

FIRST-BORN SON

1 On the Sabbath
 my grandfather went to the poolrooms
 of Novaselitz, where he smoked
 cigarettes and ridiculed
 the boys who let their beards grow long
 They were still praying
 for the Messiah
 to come—"a young Prince
 on a milk-white horse—
 He will ride
 through the streets of the ghetto
 and lead us over a paper bridge
 to the Land of Redemption."
 "Did you ever hear such foolishness?"
 my grandfather said. "They actually believe
 He'll be born
 into an ordinary Jewish family.
 Who knows? I'm the oldest.
 Maybe I'll turn out to be the Messiah.
 And if not, who cares? Let someone else
 save the world.
 You know what I'm waiting for?
 Nothing miraculous. Only a letter
 with eighteen rubles, plus
 a steamship ticket to America."

2 His horse sense
helped get him through the Austrian border
and the adversities
that came (it seemed in retrospect)
a few days later
when he found himself
with a family to support
Even in the worst of times he managed
to find a job or just the thing
to say
to get his wife moving
past the anxieties that left her frozen
and he came up
with an airy apartment on the Lower East Side
where he planned his next move—
uptown
to the green and pleasant Bronx.

3 A generation later
and my mother was still buying yesterday's
bread at the A & P, my father still working
overtime in a printing shop
my younger brother was cheated
and my grandfather said to me
"I did my part, your Mama-Papa did theirs,
now you do yours."
I was the one everyone was waiting for.

I was given Winsor & Newton paints
and still couldn't produce a masterpiece
by age sixteen
I was sent to the best schools
studied literature
with famous professors
and walked around desperate
Maybe, after all, I wasn't a genius!
How, then, could I win
a Nobel Prize?
Would I succeed, at the very least, in writing
a best-selling novel?

It was the messianic year 1965
My grandfather couldn't understand
why I threw aside my new three-piece suit
and Phi Beta Kappa key—
had he come all the way to America
to see his grandson
go to work in a ghetto
in dungarees?

4 And sometimes, on my way to a storefront
in Spanish Harlem, where I equip
Joe Delgado and Angel Cruz
with enough good English
to make them multilith operators—
sometimes I know the sadness of an exiled prince
dreaming of a kingdom that was never his.

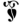

I was given Winsor & Newton paints
and still couldn't produce a masterpiece
by age sixteen
I was sent to the best schools
studied literature
with famous professors
and walked around desperate
Maybe, after all, I wasn't a genius!
How, then, could I win
a Nobel Prize?
Would I succeed, at the very least, in writing
a best-selling novel?

It was the messianic year 1965
My grandfather couldn't understand
why I threw aside my new three-piece suit
and Phi Beta Kappa key—
had he come all the way to America
to see his grandson
go to work in a ghetto
in dungarees?

4

And sometimes, on my way to a storefront
in Spanish Harlem, where I equip
Joe Delgado and Angel Cruz
with enough good English
to make them multilith operators—
sometimes I know the sadness of an exiled prince
dreaming of a kingdom that was never his.

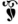

EREV SHABBOS

for Esther Schwartzman

On Sunday, when she visits him, she must come prepared.
What will she bring?
She will come alone, with only a daughter.
There is no ceremony they know between them.

She goes to the table where for fifty-five years
they sliced an apple and drank a glass of tea
before going to bed. How can she tell her daughter
what kind of man he became when company left
and for her alone he was a man of holidays.
There was no night when he did not take her
into his arms and play with her, for hours,
before going to sleep. And people thought
they went to bed early because they were old.

She spreads the white tablecloth
to set this evening apart.
And tonight, she sets another place at the table.
It is all prepared, as she prepared it for him
when he came home from work, after a week of
hauling egg crates and candling eggs.
He had strong arms and delicate fingers,
an excellent thing in a man.
And when he came home from work, on Friday evening,
he left whatever heaviness he had in the market.
There was no ritual, no ceremony between them.
She spread out the white tablecloth
and that is how they lived:
a man and a woman in the traditional way,
each one knowing the hour and the season.

In Yiddish, she writes down the words
that come to her now, and these are the words
she will say to him, when she visits the grave:
Alter, I will never forget you.
I miss you in every minute, I think of you steadily.
With a broken heart
I light the second *yohrzeit* candle. Esther.

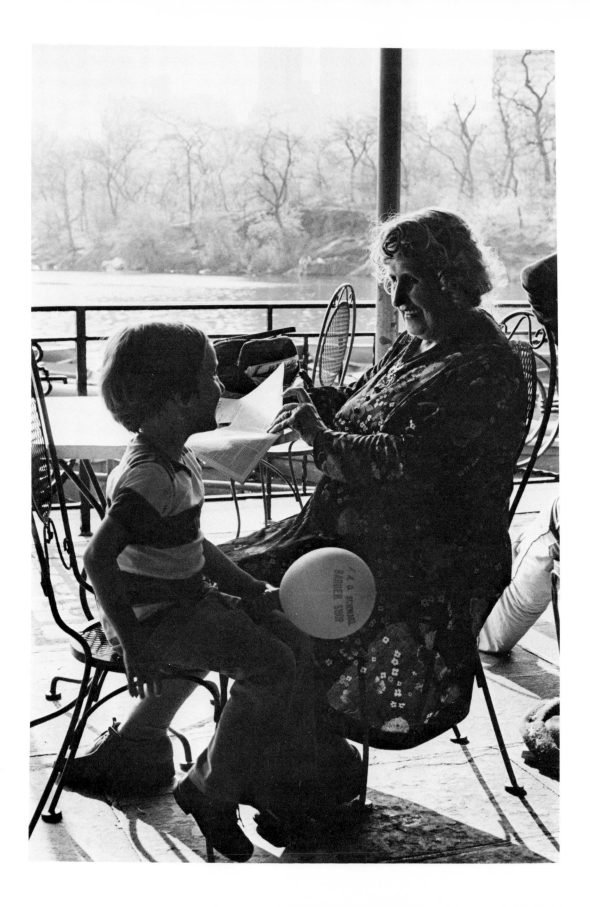

MEDIUM

How do you do, delicate Roumanians!
You, with your large ovens,
where your girls sang, baking bread!

My grandmother sings your melodies,
but without your words:
they were in Hebrew, male and sacred,

which she never knew, and I,
sitting alone with her, on the other side
of two world wars, and two years

after the death of my grandfather,
am introduced to her grandfather:
Zalman of Kostuchohn, a lumber merchant,

and her father, Baruch, who sold wine
and farm tools, an old man
who couldn't keep up with the others,

forced to run towards the barbed wire—
fell,
and was shot.

Remembering her father's beautiful voice,
the silk *kapoteh* he wore, on Friday evenings,
and the Besarabian *tish mit mentshn,*

she sings as if her husky voice,
which can barely carry the *nign,*
is joyously nine years old and joining

in with her father's, and I, too,
will have sat at the Sabbath table
where my grandmother felt herself

happily loved, still happily loving,
in an old song,
though I will carry away

neither the words
nor the melody.
On the day that I met you,

Baruch of Kostuchohn,
how close you were
to never having existed.

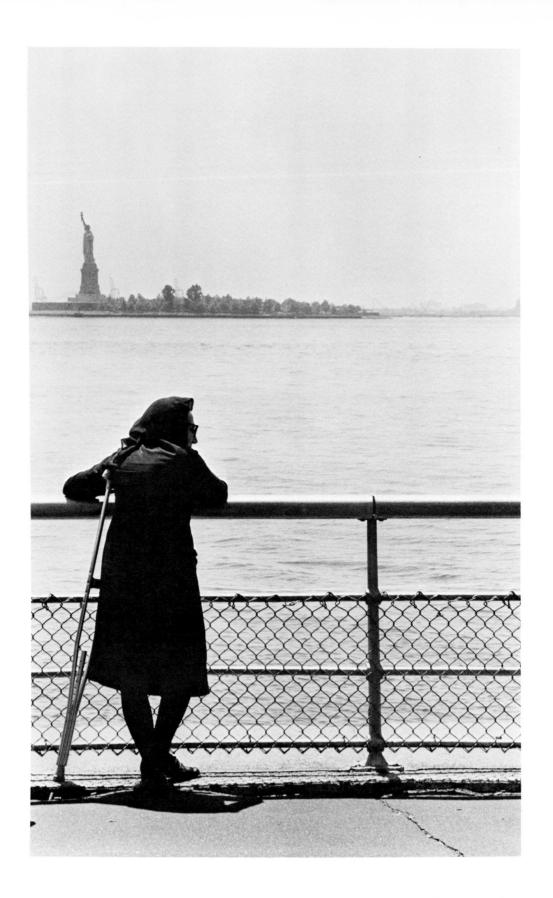

PIG MARKET

Memories not in me only, but in me through my mother's mother,
 reaching back beyond her sepia photographs, seamstress
 girls on a solidarity lunch break, her factory days
 of 1911, to her barrel-chested wine merchant father in
 Besarabia, now vanished, and her grandmother's memories
 of migration, now vanished, and memories of generations
 of fugitives, all landing at once in America, there to
 find nothing they dreamed of, the repeating history of
 men running away from women, of women being abandoned
 or leaving their men.

And memories of the *agunahs,* the abandoned ones with varicose
 veins, and three hungry mouths, and the slow wasting
 of the children's bodies by hunger, half-seen by candle-
 light, blessing the candles for Sabbath, helpless

And the men running after a living, breathless, peddlers,
 piece-workers, jabbering Yiddish, thousands of men
 on Hester Street, called the Pig Market, and the boss
 shouting You, you, and you, three out of ten got work,
 eighty-five cents a day, sixteen hours a day, a year
 gone, and no money saved, helpless, no candles to bless,
 Gold Street not the name of a place but another false
 messiah in a long succession of false messiahs, another
 letter sent back home without rubles, without the
 steamship ticket promised a year ago, seven years ago,
 in the stupid hope of the setting out

They carried their sewing machines on their shoulders,
 walking the streets, nowhere to go, the women at home
 growing beards, getting stranger, feeding their children
 on "tongue sandwiches," a slice of Yiddish endearments
 between two slices of thin air, the men desperate,
 casting humpbacked shadows on tenement walls, looking up
 cousins they would never have spoken to back home, who

spanked them in the toilets for a mispronounced phrase
of Gamara, meals of humiliation, bread of affliction,
another Passover in America, ready to spit, close to
tears

How many men left how many women, running away to Milwaukee,
running to California, Jewish cowboys, Jewish gold
rushers, how many women suffocating with fifteen people
sleeping on the bedroom floor, traveling steerage class
from birth to the end of hope, how many women, the
agunahs, putting their heads in the oven when there were
no words left for a tongue sandwich

Or putting ads in the *Daily Forward*, whole *agunah* sections,
how many women, the repeating history of emigration,
and mug shots of how many men, cursed to work without
hope, If Moishe Leib reads this, if Zev Aaron reads
this in Chicago, let him think of his faithful wife
Rivkah Leah, let him remember his devoted wife
Dvorah Esther, with whom he stood under the marriage
canopy in the eyes of God, with whom he conceived
Mani, the light of his father's eyes, who goes without
shoes, with whom he conceived three precious daughters,
let him remember Benjamin, his Kaddish, who mixes with
bad company, with whom he begot Fanya, who left the
ways of her fathers and is living in sin, with whom
he begot his seventh child Reuven, who still remembers
his father and continually cries out for him, let
him remember, if he reads this, in California, in
Chicago, anywhere in the West, may it find its way
to him, and let him return, if he reads this, let him
think of his wife and children without rancor and let
him turn to us and let him return

Strange women stepping off the boat with thin bundles, his
 children, and is this what he worked for, one year,
 seven years, this family that he no longer knows,
 who no longer knows him, the repeating history in me
 of the separation of how many women and how many men

Or the women in Besarabia, or the Ukraine or the outskirts
 of Warsaw, feeding themselves on infrequent letters,
 eighty-five cents a day, and no steamship ticket at
 last, no safe passage into America, and the radiant
 Yiddish, the Yiddish of blessings, Yiddish of the
 mystical spheres of splendor and the song of the bride
 of Sabbath, Yiddish of hope, losing all touch with
 the sky in the Pig Market, the boss shouting You,
 you, and you, and then later it was full of disguises,
 the girls in the tenements hitching up their skirts
 and pouring pitchers of water into the hot tubs,
 or bending over ironing boards with half-open blouses,
 boys of nine sorting and marking the laundry, the
 Yiddish of holy sparks giving way to a bookkeeper's
 tongue of how much earned, how little saved, and
 apologies, mixed with prayers for forgiveness, until
 the men couldn't bring themselves to write any more

How many men in the repeating history of failure and running
 away, and taking up other names and other families,
 and repeating women how many lives in memory living
 how many repeated lives in me, fugitive, working,
 conflicted, saying in a language losing all touch
 with the sky, You, you, and you!

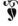

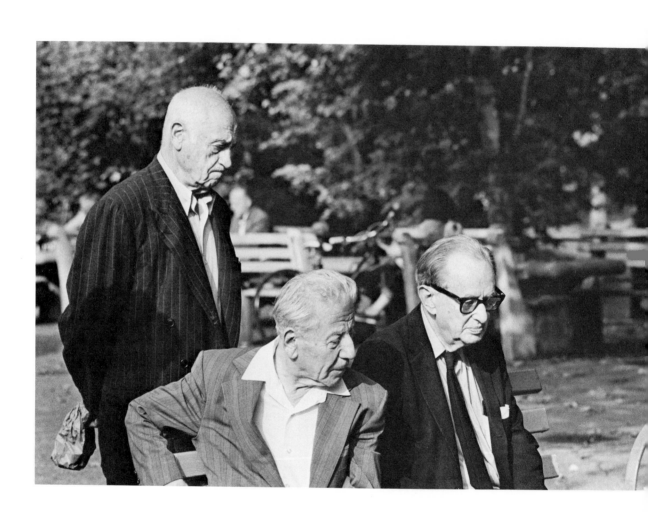

MANY GHETTOS

How do they live, twisting
the buttons off each other's coats
and standing in the mud, arguing
whether the spit of a mystical bird
is kosher or *treyf,* elated
with each new turn in the argument,
with their determinisms and herring,
with tobacco hidden in the attic,
with edicts hemming them in
on all sides, with kinsmen
roaming freely abroad,
organizing the leather workers
or managing large estates in Galicia,
with a bad reputation, with the Torah
instead of a lordly acre to plow
or the means of production,
with their love of old shoes,
with the peddler's pack,
with the peddler's pack,
with a glass of schnapps, with a fiddle,
with four competing utopias,
with three silver candlesticks
in a pillowcase, ready for flight,
and memories of the back alleys
and back doors of a thousand cities.

How is it they never seem to get anywhere,
with their beards shaven off
and a new pair of names,
with hoping to please, and a magnifying glass,
with progressive slogans, and a backward glance,
with a pinch of salt in each pocket,
with fear of the Evil Eye,
with a valise full of samples and an old bag
of tricks, to avoid being noticed,
how they long to pass by like anyone else,
how they long to forget themselves.

In a moment, they're afraid,
they will be forced to remember.

LIVES OF THE POETS

for Yvette Mintzer

I'm fairly bourgeois, I see
that no great adventures are coming to me,

and the years that my friends spent in Spain
to cultivate their art at cut-rate prices

were largely wasted. I still dream
of Nevada, of building my hut

on the side of a mountain, and emptying
my life of its bourgeois contents.

I'd have to get rid of my electric blender,
my filing cabinet full of odd city notes,

and I'd have to learn to behave
like a goat, if I were going to survive

the loneliness and boredom I'd feel
as a nature poet.

Me, with my fascination for the heartbreak
and pratfalls of family life,

with my great love of walking among the Hasidim
of Borough Park, and the whores of Times Square,

with the fingers of time stroking my hair
on the Columbia campus, and my gusty sense

of well-being on Riverside Drive, and of being
on sacred ground in the Garden Dairy Cafeteria.

There, I imagine my ancestor Mani Leib
stealing a twenty-four-hour lunch break

from a shoemaker's shop in Brooklyn
and meeting the brash despairing Moishe Leib Halpern

for tea in a glass, and a cube of sugar
under the tongue, and a rush

of pain-dissolving images which held them
together in a ferocious exchange

long after Goodman and Levine closed the cafe
and they wandered by roundabout ways

and sidestreets to a wonderful place they knew,
a lumberyard near the river and Tenth Street,

and there carried on until sunrise
made them remember their wives and their jobs

and their greenhorn flats
and the long trolley ride back to Brooklyn.

Me, with my feet in the Russian Pale
and the back of my head resting on the corner

of East Broadway and Canal Street,
how should I drink in the kind of stuff

that might nourish another man's life
but would leave mine parched,

and not like a dried leaf either,
but like a page in a strongly bound book

from which all the old words
are in Yiddish and crumbling.

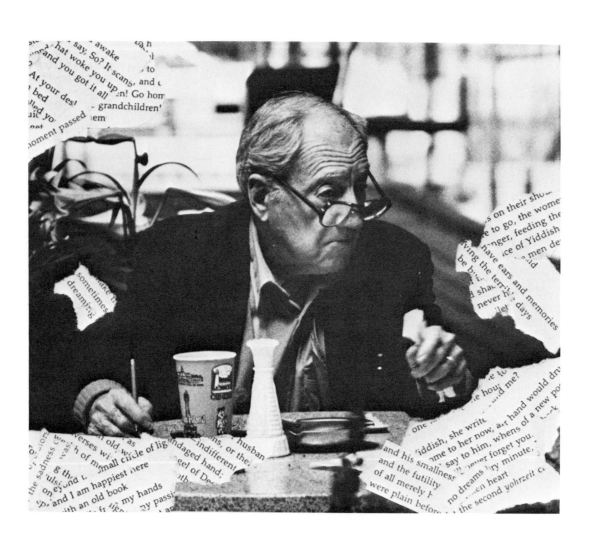

REMEMBERING LUTSKY
by Rayzel Zychlinska

Today I was awakened by the moon
that suddenly remained
in the empty sky,
and maybe by the dead poet
that still makes his rounds
in the cafeteria?
In his green bow tie
with his book in his hands
he still makes his rounds
in the cafeteria.
He reads a new poem to colleagues,
asks their advice,
quarrels,
erases.
I still go there, looking for him
among the empty tables.

Translated from the Yiddish

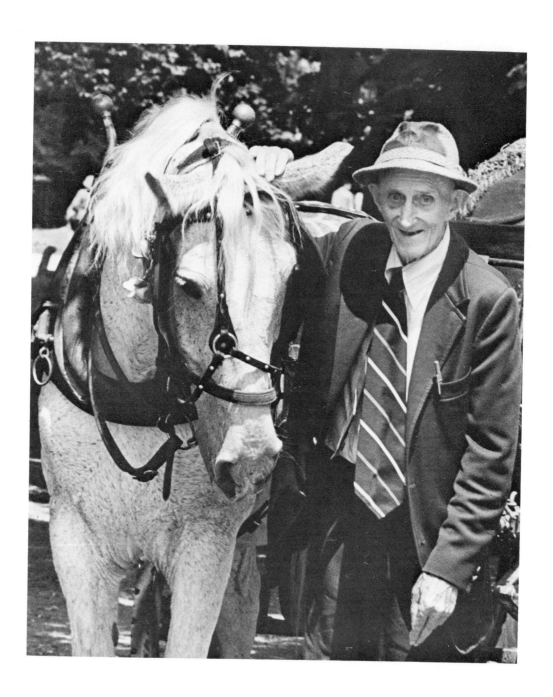

RUMMAGE

I love the poorer sort
of antique shops
that are really just collections of junk:
a pair of spectacles
through which living eyes
once mastered the essentials of English,
a spindle
whose first cousin
might have been whispered to
by Morris Rosenfeld in a shop
on Eldridge Street,
a comb
that accompanied a recently buried widow
across the Atlantic,
a gift from her mother
at the time of marriage—
objects whose one value
is that they were cherished
by imaginary kin,
in them I trace
a saga of emigration
to a world that's no longer fresh
and feel
the etherealizing power
of long usage
which transforms small things
truly needed
into relics.

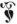

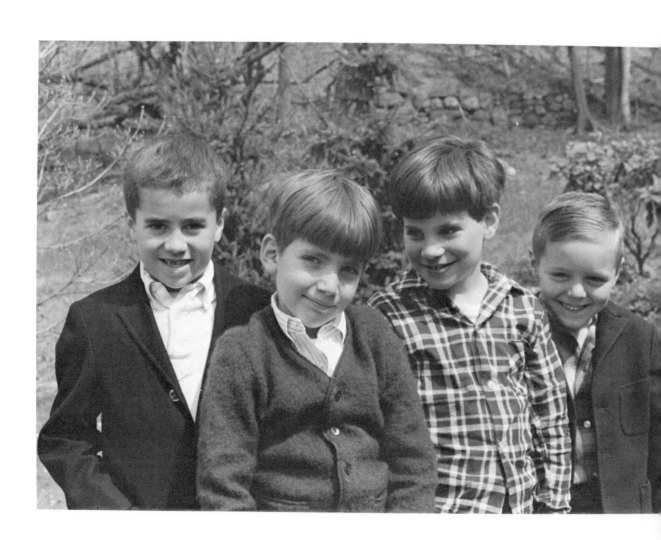

GOLUS JEWS

Junk men, the last of you
trudged through the Bronx 20 years ago,
sharpening knives and doing Lord
knows what with umbrellas
and calling up to the empty windows,
I cash clothes!

Somehow you managed
to get your nags and wagons
across the Polish border
to Mt. Hope Place and the Grand Concourse
and fill them with American newspapers
and mattresses whose coils
were made in the steel mills of Bessemer.

And I was already on my way
to the third grade where I was learning
to admire microbe hunters,
conquistadores and a pantheon
of 18th-century Virginia country gentlemen.

Grandfather junk men,
on what plantation or Aztec field
was I being inducted
into the victor's dream of history
while the last of you carried the Old World
through the streets,
muttering psalms of David under your breath
and fingering your *tsitses*
to drive off alien thoughts?

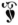

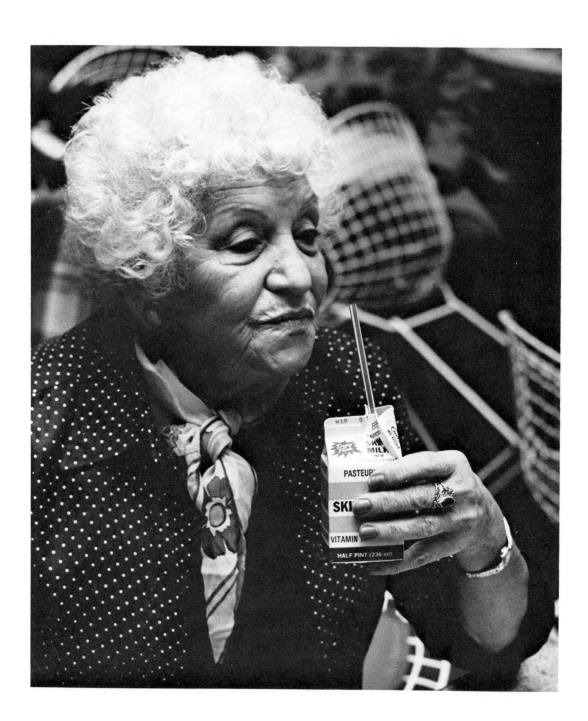

MILK

My sister, with her baby
beginning to bawl, slings her
around onto her hip
like a Bushman woman,
lifts her blouse,
the baby's head plummets
to her breast—
then the hush, the happy and active hush
of suckling.

My mother's delighted.
Laughter that's wholly laughter
breaks
in waves
from her rounded lips
She's thrilled
by her daughter's insouciance.
"I've even nursed her
in a restaurant. I ask you:
does anything show?"

A green blouse, in billows
about the bald head . . .
The neighbors flocking past us
don't take in
what they're seeing
And who would expect to find
a woman nursing a baby
right here
in the lobby
while she stands and waits
for the elevator

We've just come from the hospital
where they've taken my grandmother
off solid foods.
She lies there and is hardly there—flat white
as the white sheet under which
she hides, except for the eyes,
two black whirlpools
she turns on me.
"Can you help me? I can't cry."
And just as the first tears come
she starts to throw up.
For the third day
she can't stomach anything
And she knows
she will never again be able to hold down
her milk.

And my mother (all white hair now),
with her mother
dying a few blocks away
and her granddaughter having just come
into her arms,
steps into the elevator and
the baby throws back
her head, to burp
and coo and sigh—she's singing!
A first song! She's in paradise
And my mother cries
easily, laughs easily
on this pinnacle
of her life—transformed
by her new mobility
between delight and anguish.

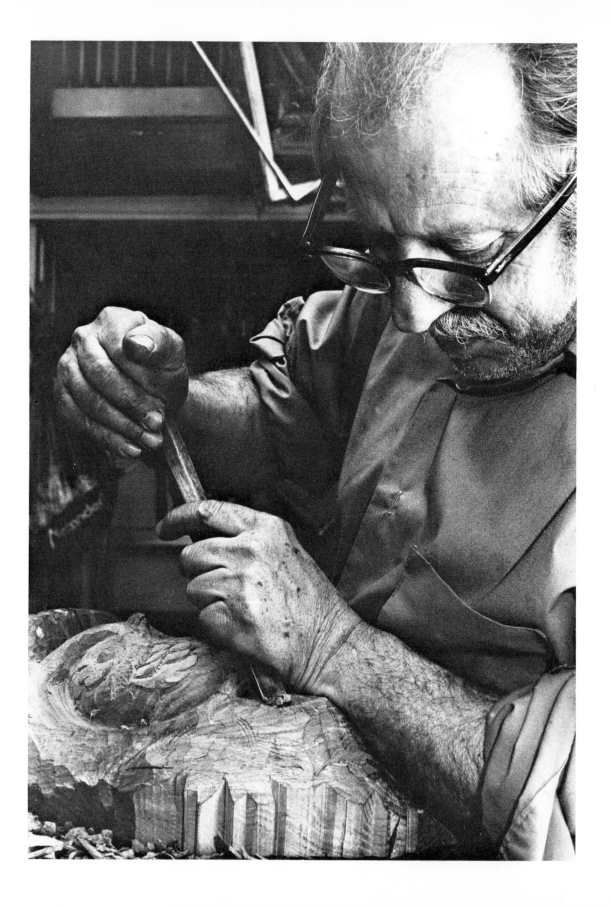

II. PORTRAITS

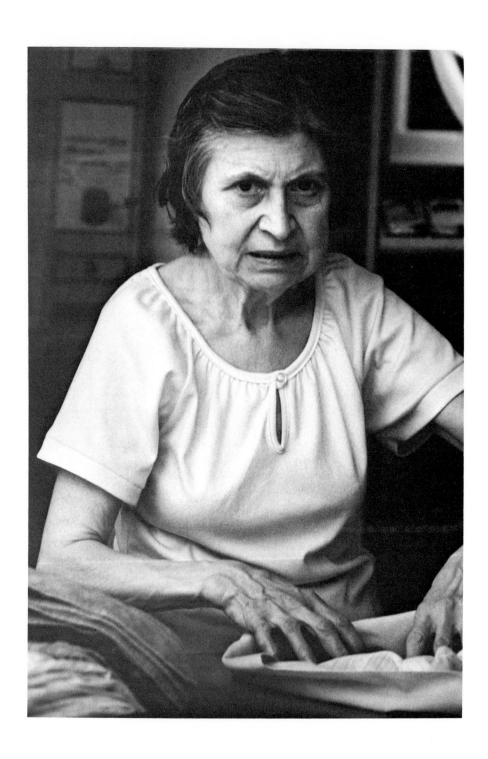

WAKING

What's she doing down here
with these starched limbs
that hang from her neck—so creased!
Where's the body
she used to get up in?

She feels she can no more
wake up and walk
than a pile of laundry,
the denims and calicoes
dropped in a heap

give off an odor of work.
And this day too
will bring her many things
that need washing.
Her fingers stir, her hand

caresses the bedsheet,
and gradually
it comes back to her:
even in heaven she'll go on
washing clothes.

As daylight fingers
the shutters, and reaches in,
she sees the hand of God
on the ceiling, bones of light
draw the room wide.

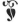

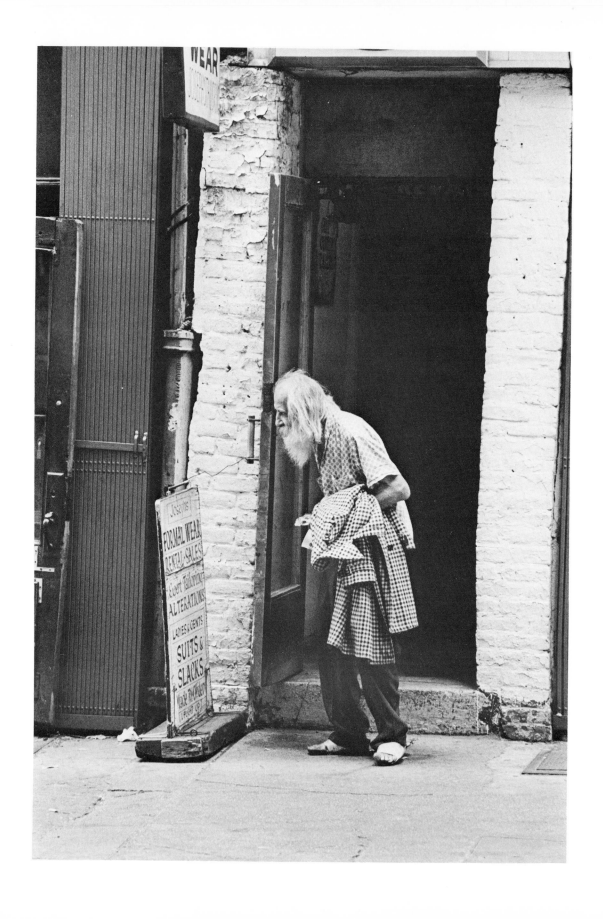

HARD TIMES

You lived without money
and with money
so hard to come by,
you handled it like a fragile thing
and used it for necessities only.

You learned to make underwear
out of gunny sacks,
coffee out of parched chestnuts,
you turned orange crates into armchairs
and put newspapers to so many uses,
lining your roof and shoes
with society pages,
until the headlines were worn away
and the paper was once again innocent.

Whatever you had, you held precious:
the wood-burning stove
and your daily bread,
the soil and its produce,
the lamp was kept trimmed to a low flame
that lasted until bedtime.
You took what you could get
and made light of it.

It's what you always came back to:
to drink the water, to eat the bread,
to use what you'd been given
to work with
sparingly
and lightly, the way your fingers
touched a dulcimer or guitar,
to cultivate the art of survival.

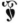

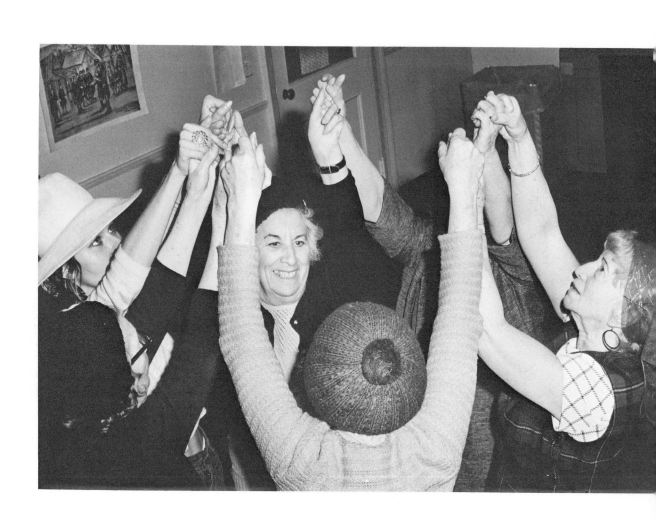

DANCING

Would you believe
I danced this morning?
We had the TV on
and I heard the music
and it went to my feet

I went this way
and that way
I lifted
my hem up and kicked
like this:
I did kicks like a chorus girl

In Florida that's what
I do
and they shout: Take it off!
I unzip my dress
just a little

Would you believe
I danced this morning!
My husband with his stroke
he *kvelt* and told me:
Lil, you'll never get old.

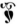

—*spoken by Lillian Glick to M.K.*

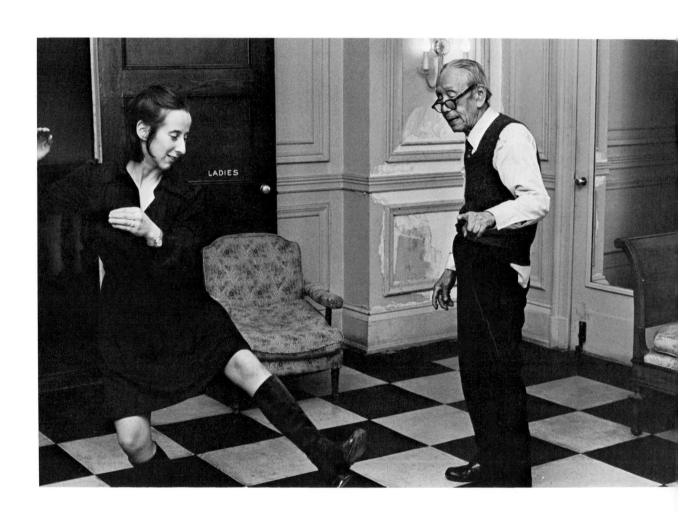

FLYING

Studying T'ai Chi
with an old Chinese teacher,
the girl gets
her left leg accurately into orbit,
but the glass ball
which she should have correctly imagined
with the arc of her hands
slips to the floor.

Sympathetically, I observe
the stupid expression on her face.
How painful to learn anything,
anything at all,
at the hands of a master!
But how many are given the audacity
to be put off balance, and still
to imagine
that they are one of the lucky bodies
moving through space
effortlessly on a central axis?

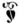

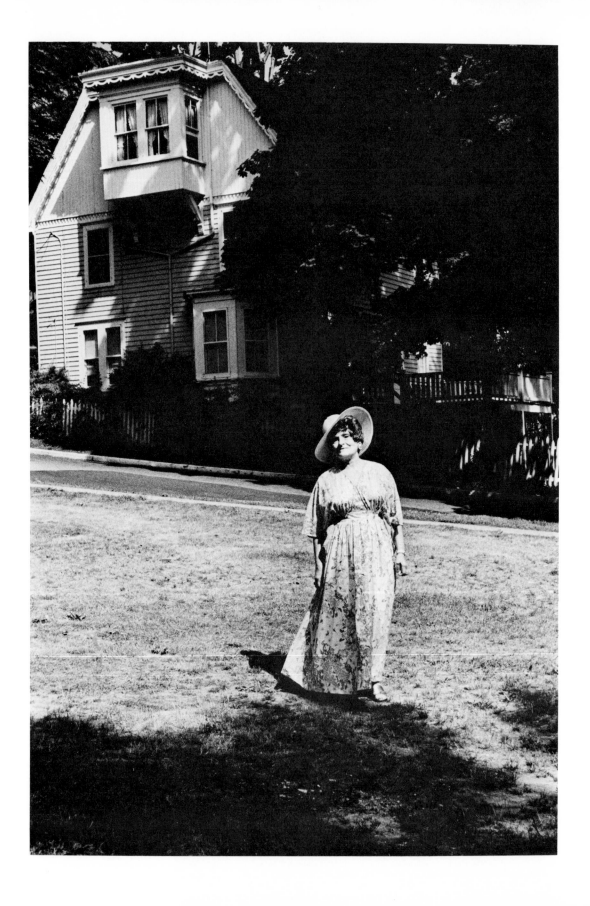

REVERIE
by Rayzel Zychlinska

The clothes in which you saw me—
they'll never get old,
with all their colors
they go on blossoming in my closet.
The violet dress is whispering to the green
a green and grassy secret,
the rose clings to the yellow
and at their hems
flowers continue to blossom.
Removed and special in a corner of its own,
its arms thrown over its shoulders,
my blue dress is dreaming of you.

Translated from the Yiddish

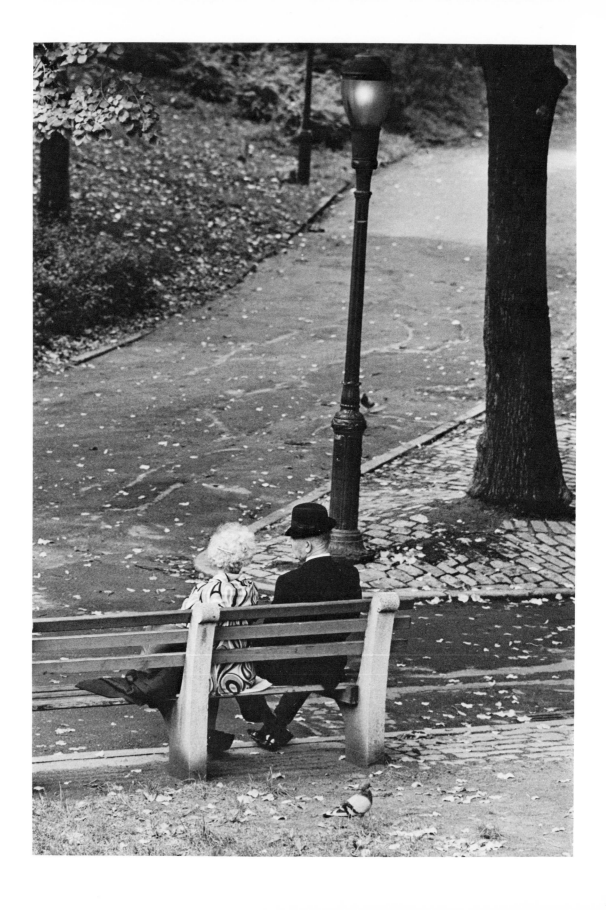

WORDS THAT ARE BARELY SPOKEN
by Zisha Landau

Dina, there are words that when barely spoken
make light of your mood, but you never say them.
Only from time to time, when you stop
listening to the words that you speak,
wonderful things fall indifferently out of your mouth.

But you know nothing about it, except afterwards
you realize something terrific has happened to you.
And you say the things you've never been able to say,
you see in a way that you've never seen before,
and everything towards which you move is joy—
oh, Dina, there are words that are barely spoken.

Translated from the Yiddish

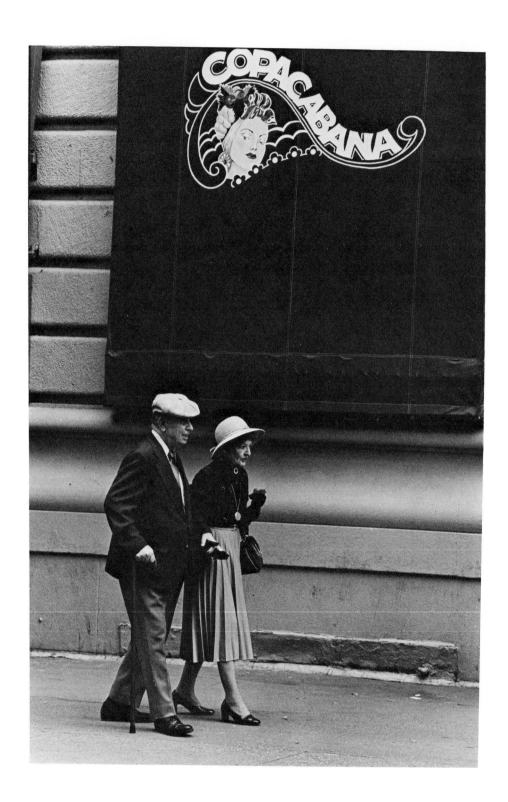

A WINTER VACATION

Before a trip outside
her outskirts
the housewife is beside herself
She spends her late minutes
at a mirror, attached
to a door, bewildered
The woman in the mirror
looks at her through narrowed eyes
and wonders: who is this
other woman
the one my husband takes
when he leaves the city?

She wishes she could
take the cat, with whose mother
she came into marriage
Her Singer is folded away
into the work table
her patterns folded up
in the sewing box
How little she can take with her
in one fat suitcase!

Now she's faint
on the sofa: difficult
travel didn't end
when they last returned home
and hasn't begun
She needs time, a little more
time
to take leave
of the hard-won order
And why run off with a man
that she hardly knows
and go back to
the weightlessness she felt
before they kept house
why return
to the romance
of those hazardous days?

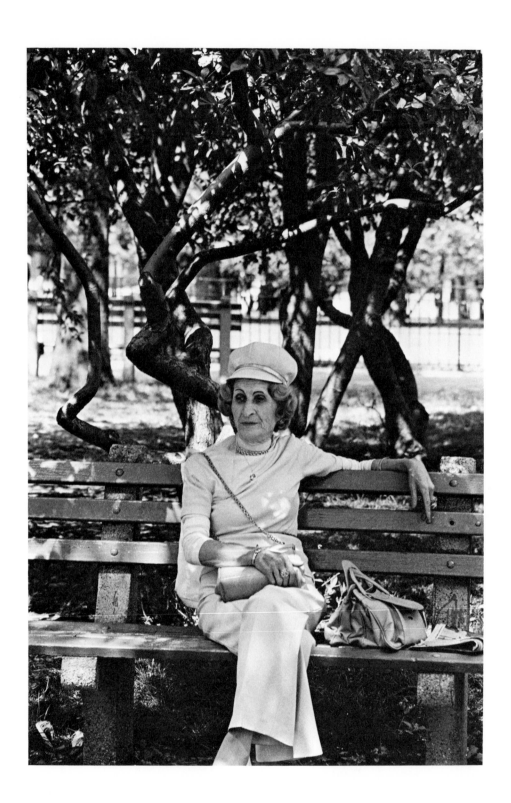

ESTRANGED

What is she doing housed on a golf course?
Dieting? Dyeing her hair orange? Preparing
her husband's shirts for the black maid
to iron? Is it Sunday night? Is it living?

Tomorrow, what shopping malls, what errands
will she accomplish? She'll go
to the orange groves and the Italian tailor,
she'll make accommodations for the friends

from New York. Does the gold hinge
of the box where he keeps his beer nuts
need repairing? With expert fingers
she'll consult the Yellow Pages. Then what?

She'll find baked farmer cheese somewhere
in Florida! Once she studied languages
and raised daughters, but that was in Brooklyn
where he would never have let her

stay up alone, late, in a bathrobe, turning
the pages of the Arts & Leisure section.
Why is he always going to sleep early
and earlier? Why does he roll up

the sleeves of his jacket? Why did he have to
move the business to Florida? She doesn't know
whether to take up astrology or investment,
join the synagogue or the tennis club.

Their enclosed veranda overlooks the 9th hole—
a few pineapple palms on a wide plain
and some kidney-shaped ponds surrounded by swamp
grass, alive with egrets and alligators.

She watches them lumber across the greens
from one water hole to another
and can't imagine that her father swindled
his way out of the Ukraine and peddled cigars

on 49 years of streets and insisted she learn
French and piano and the manners of a lady
so she might end up with this—a beautiful view
of a veldt that doesn't resemble her own.

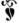

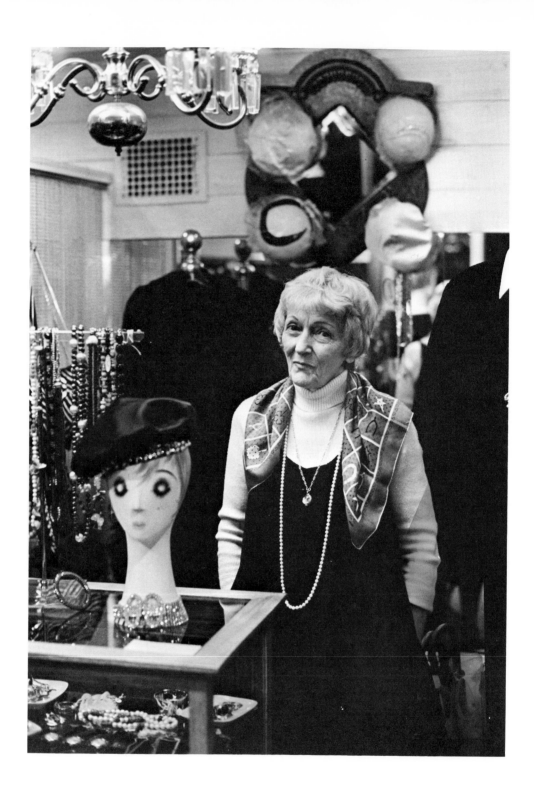

SALES LADY

No one will get
the better
of her She takes

charge of every
transaction
with the crook

of her head Her
disdainful
smile has practiced

on better men
than you
and made them

feel the shabbiness
of their origins
or their failures

in love or in
business
It is the smile

of a polished
waitress
or a grande dame

in Proust, which tells
the approaching
client, I know you and

your kind, you're cheap
you're disappointing
and cheap

I don't think you'll find
what you're looking for
in my boutique

But if there's any
virtue in you
any real class

you'll put yourself
into my hands
Young man for you

I'll take the palms
out of my pockets
and serve you and you

will be grateful
if I let you leave
your money behind

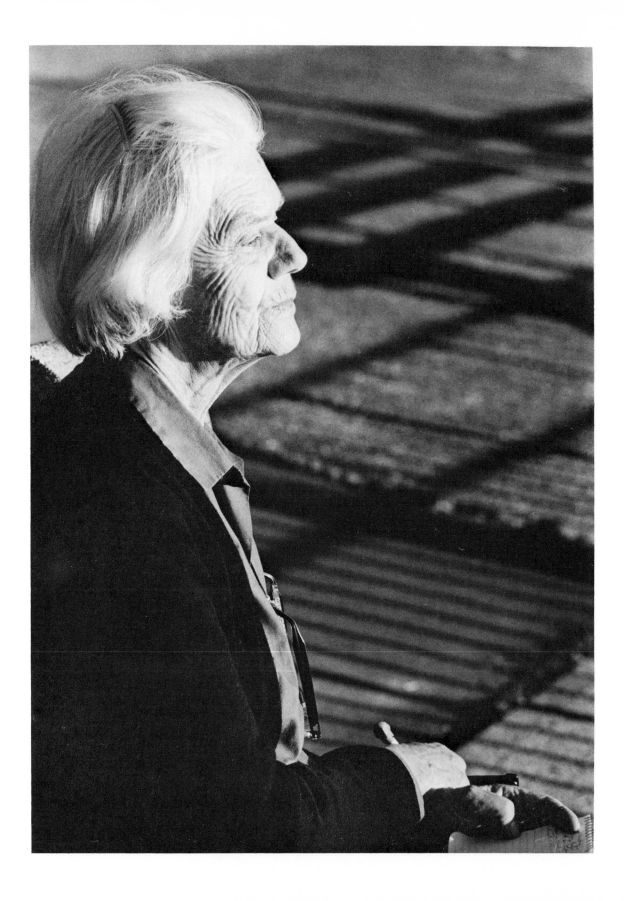

NOT SPRING, NOT WINTER

And then one Tuesday
you find the uneaten bread
has gone stale
The ground is covered
with irrational absence
neither snow nor grass
but only bars of the sun
quiver in the blinds
and you watch them
slide into uncertain darkness
along a well-patterned rug
Don't you recognize the signs?
Your mind is leaving
one of its used-up seasons
and you are bored with your life.

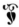

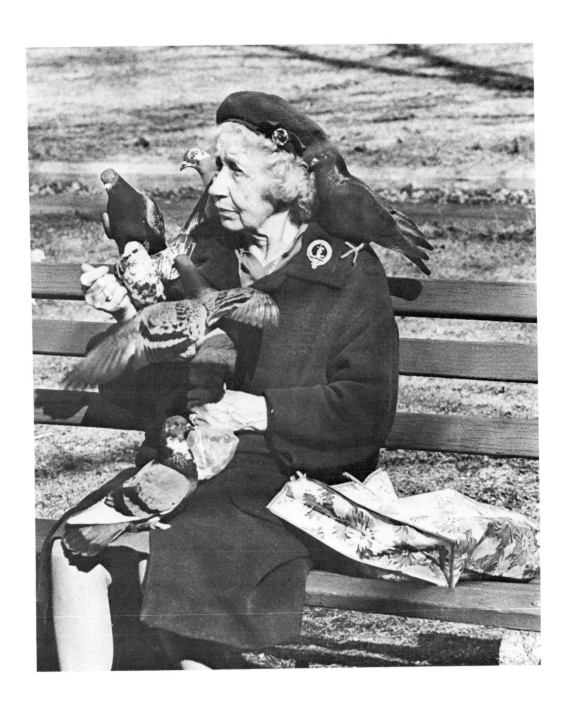

WHAT THE PSYCHIATRIST SAID

The woman has poor social technique.
She uses her terror as a tool.
She hears her terminally failed husband
screaming inside the radiator.
It's time to blow the whistle.

Take this case which so openly displays
the essential mechanism of despair
and deliver it with extreme care
into Kings County Hospital.
There will be no more neighbors
to offend, past one o'clock.

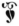

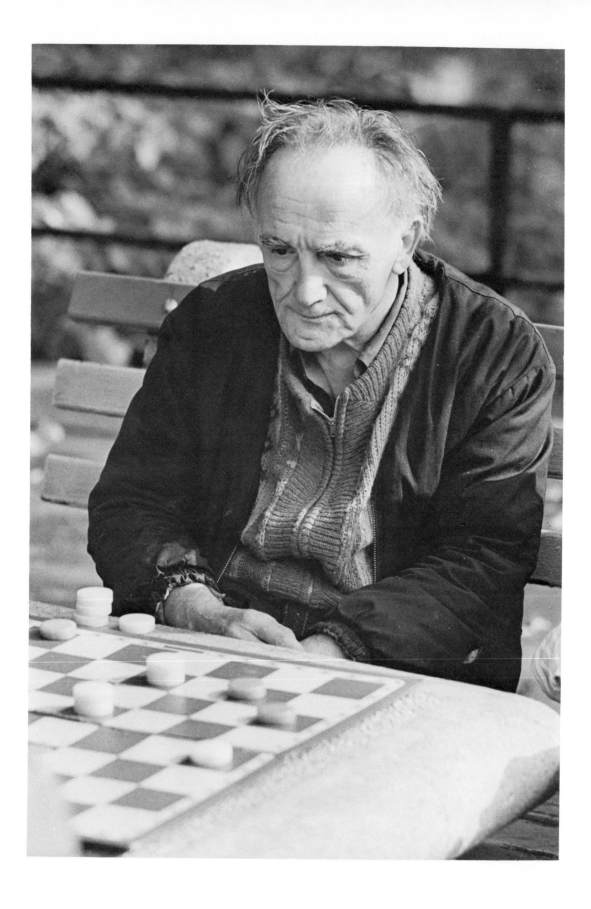

A GAME OF CHECKERS

Three layers of clothing
will not protect you
from this cold

Your large hands are limp
They have outlived
employment

Clearly you have committed
manual labor persistently
and at base pay

Now you sit at the end
of a bench
in a public asylum

where all are free
to come and go
once they have nowhere

Facing an adversary
twice-kinged
and (to me) not visible

you stare intently
at the board and wait
for a happy thought to pull

you through
And though your mind reels
among delusory calculations

you know
that anywhere you move
you are lost

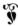

THE ENDING

There was a hole in the floor
which caught her heel
and she fell, cracking her hip bone

and the voice which is always going
on under the passion
said in a neutral tone

"This is the end."
And when they carried her off
to the ambulance—"It's the end."

And there was a niece who flew in
from the coast and stole everything:
her black silk scarf with gold

edging, which was a gift from one
of the stories one never gives up
her wedding ring, her silver

cigarette cup, and all
that she couldn't carry off
in a suitcase

she sold
to a secondhand furniture shop
for three hundred dollars.

"I couldn't let you go on living
in that ratty hotel room.
I was planning to put you into a home."

And there was nothing to return to—
her only kin
had been so eager to have her die

she had already scavenged the last
few pieces that connected her
to love: her husband and her sisters

and her friends, now utterly gone
from the room. Only the radio
brought her guests on an all-night talk show.

Towards dawn, when waking bitterness
petered out, there were nightmares and cops
who broke in. She told them

that her niece had come back again
that she awoke and found her
standing over the bed. She screamed

and her niece, rushing to get
away, ran into the closet.
"She's in there now.

Look what she's done to me.
The joint's empty. Arrest her.
This isn't my room."

And the Spanish cop said
"It's only a bad dream, Lilly. Things
will look different in the morning."

And there was the sky at the window
an old white place, like a bandage
over the roofs of the Welfare hotels

beckoning her high above Broadway.
And as she walked towards the window
the voice which is always turning

80

shocks into stories
said, "And then I went to the window."
But her joints locked

she couldn't climb out.
She and her arthritis were stuck
there, five stories away.

And there were the days which came after
which were days of coffee and toast, and coffee
and toast, and a partial recovery

and the nights brought fantasies
of a man with a knife
who would break through the door

and put an end to her vigil.
She had lived
beyond what should have been

the crisis and the quick descent
and the voice which had already spoken
"Finished! finished!"

was waiting for something
which didn't happen.
There was the danger then

of not being able to foretell
what worse
would befall her, what worse

would she yet
have to
live through?

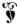

THE EMBRACE

1 A man who lived in that building
stopped her on the third floor
and asked her where she was going.

It was the unknown place
that she had come to twice before
and she was so firm in her silence

he muttered good-day and let her pass.
By the time he got to the front door
she was already there, having jumped.

2 Others who knew more
than that man knew
could not have stopped her.

She had more
than the desire to kill herself
She had the desire

without which suicide
never occurs:
the desire to die.

She told her mother
that next time
she would jump off something

and everyone waited
for the time
that we knew must come

when she would once again
take her life
into her own hands

and do what the terrible law
of dignity
requires of each of us:

for surely we are all inmates
and insane
until we accomplish our desire.

3

There is a painting
by Giotto
of an old man and a woman

who meet on a road
and there, and with much restraint,
they embrace.

I no longer know
whether they have been blessed
in their old age

with a son
or whether they have just had news
of the loss of a son

but the biblical occasion
no longer matters
for the embrace itself

has stayed in my mind
many years
and now I realize it is

one of the great memories
to which one keeps coming back
at the renewal of confusion.

I know now
it is the one gift
that we have

for living
amongst our species—
an embrace

that is neither of consolation
nor of thanksgiving
but of a life

in which both are real
and acceptable
And I know

that if I could permit no one
to bless me
or share my grief

if there were no one
with whom I were wholly delighted
and hopeless and there

if in the arms of my mother
or last few friends
I felt only an absence

I too would climb
the desolate stairs
to the top of the nearest building

and with so much desire to be embraced
by death
that I too could persuade

even the most vigilant
guard
to let me through at last.

4 Having come to my own house
after the burial
of my cousin Kay

and brooded on her last
few hours
and her final encounter

on the stairs
that image of the old man
and woman came to me

And then I imagined
that the old man of the building
had stopped her

and so embraced her
that she were now safe
in her bed.

Ay, but by our very fantasies
we come into the truth:
for in that absent embrace

I saw the thing
she had died for lack of
and how necessary it was

that the old man let her pass
and that she go unmolested
to her grave.

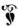

A FABLE

in memory of Charles Stanley

Listen:
it makes no sense in the way our lives don't make sense,
 which is why the fable is made in every generation,
and why we listen, like enormous children, in the hall
 of a frightening guardian:
it is the story of the task that is not accomplished

and the wanderings that bring you no closer to the goal
 that is one day simply abandoned,
and the prize that you set out to capture and bring back
 to the place where you started out from
continues to reappear at the edge of your life, like
 the hunted creature in a fable, moving
always at the edge of your life, to spoil your life,
 until one day it is simply forgotten,
and the place where you started out from leaves off
 being returned to,
and the person for whom you began the fabulous adventure
 is replaced by another person
who waits for nothing you can possibly bring her

and the wanderings that come next lead to nothing
 but an ordinary room
with burlap curtains over the window and a chance
 acquaintance with whom you sit down to supper,
someone who pours you tea from a clay pot and whose hair
 is covered with a brown babushka,
and there, in the late hour, you remember by what
 indirect roads and byways,
with how many stops, in ordinary chairs and beds, with
 the ordinary feelings,
with how many ordinary losses, you came to stop here.

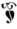

89

III. COMPLAINTS

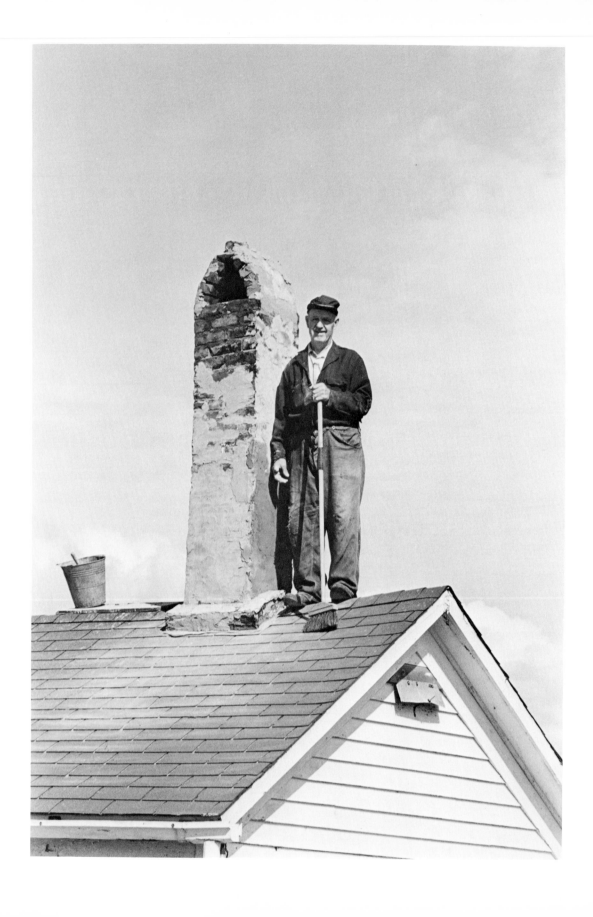

WHO ARE YOU? WHAT DO YOU DO?

Kamina, they told me
was Russian
for hearth or stone
and when the Czar was clapping
patronymics
on countless Ivans and Abrahams
a certain eighteenth-century "son
of a chimney sweep"
was named the first Kaminsky

How close they felt
to all that was
royal and holy and family

The peasants
came chanting through the town
mud
carrying icons of Mary
and the Jews escorted the Queen
of the Sabbath
out to the rye field
then everyone fell
back to the eternal weekdays
loyally subscribing to the names
they had been given
to work with

And I also grew up believing
what the old patronyms
told the masses:
 You are the chief
 property
 you inherit from the father—
 the work you do

So it doesn't matter
that Kaminsky the chimney sweep
probably never existed
For most of my life
I have been his
son
getting myself in and out
of tight corners
and making the rounds
with a number 2 pencil instead of a broom
for hire

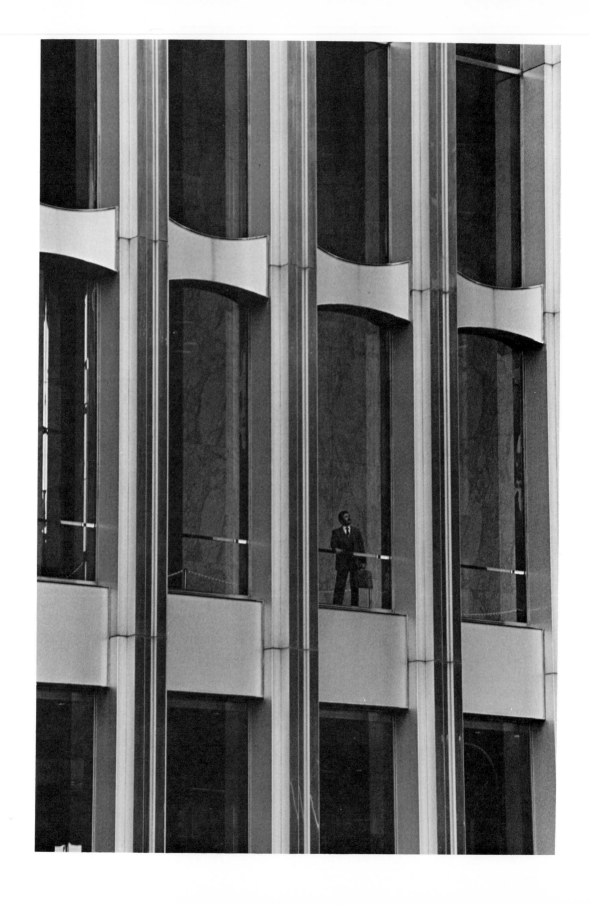

A YOUNG MAN IN AMERICA

He strides down the Avenue
of the Americas
where the architecture plays a triumphal march

In the *Times* it says
there was a putsch
in one of the skinny countries last Wednesday

And then on Tuesday
the Puerto Rican janitor falls
his face turns blue, the firemen can't revive him
they blow 50 gallons of hot air
into his lungs, kissing him
full on the lips. It's shocking.

He throws his box of Marlboros
down the incinerator

Suddenly the allegations of political torture
seem plausible

But three days later
and he's smoking again

And the moon comes up over the Hudson bay

Then he sees clearly
There is the Statue of Liberty
there is the Brooklyn Bridge
there is the Chrysler Building
with its golden spire
he's in a sparsely furnished room
at the edge of Staten Island
the rooms are piled one on top of the other
he's living in a house without cellar or attic
there are no more Californias
he must land
a job

So he wanders in
and out
of glass cliffs with tight security
There, he submits to interrogation

The Indians are on the reservation
the women are in the typing pool
the old ones are in the waiting room waiting
all the seats are taken

So he rides the subway, thumbing
through Chrétien de Troyes' *Perceval*

How far he feels
from his excellent days at school!

His daydreams carry him
beyond the chapel-like reading room
where he loved to confuse reading
with daydreaming

and he sees his grandfather
carrying the emigrant bundle
out of Russia
and his father carried the lunch pail
to a printing shop—
so that he could carry this attaché case
through Lower Manhattan?

A few miles from the gates
of Columbia College—
and he feels once again like a dark
tattered I-cash-clothes man

At night
the Cossacks ride brilliantly
back into his little ghetto of sleep.

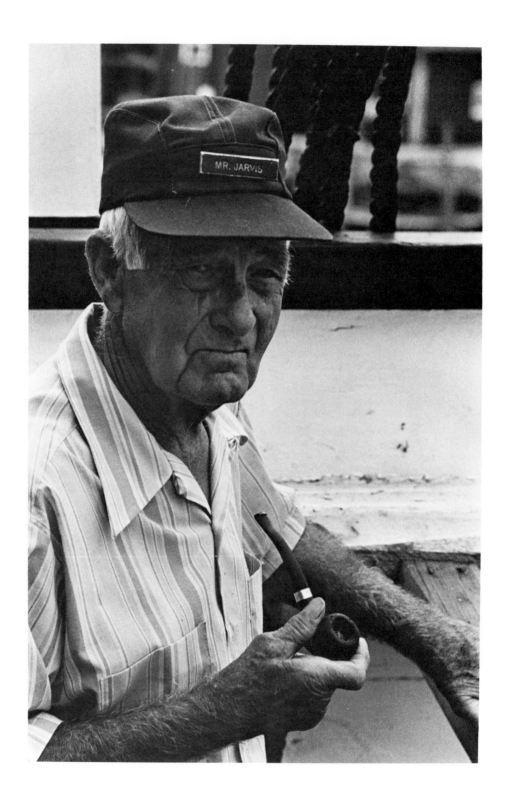

THE COMMON ROUTINE

A child is permitted to dream
of adventures
that do not make money,
but all along he is being led down
long tiled corridors
to a room where he will be granted
a cool florescence.

By the time he knows
he is wilting,
it's too late:
he's taken root
in his cubicle, working rapidly
on forms
that bring in the money.

Sometimes, at four in the afternoon,
he wants to run out and grab
a cab to the airport.
But where would he go?
This is the desk
where he's permanently grounded.
These are the black steel drawers
where he must file
his growth.

He watches his hand, clamped
tightly around a lead
pencil, carrying figures
across the pre-coded boxes,
across the days and the small portion
of years that they come to,
and how anxious he is
for that weary traveler.

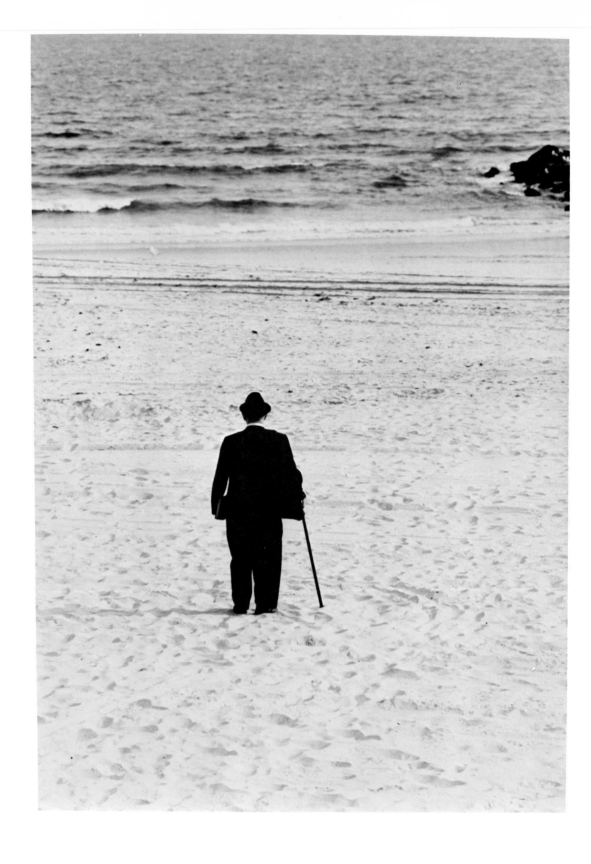

HITTING ROCK BOTTOM

for Rose Dobrof

Tears in the eyes of an old man,
a baker taking leave of his wife.
A wheelchair attendant takes her away.

And the nursing home takes the whole of his union
pension, those thirty-nine years of labor,
when he dreamed, in the end, of long late breakfasts,

of beaches which would bring a lost abundance
to friend and dear friend, and of a life's companion
with whom he might stroll, for a while, in the late

afternoon, through the parks of Rome and Jerusalem.
Now he walks on Avenue U, under the El,
and somebody's there who walks beside him

and works at him with a handful of questions.
He throws open his arms, and cries,
Can't you tell when a cup is empty?

The body of a vigorous woman once filled
that embrace. And then, for two years,
after something burst in her brain,

she continued to fill his arms, for love.
He lugged her dead weight
to the bathroom, three times a night,

he cleaned her urinous garments,
and in the evenings, after
he dressed her for dinner and fed her

chicken or fish, he would sit with her
in the living room, for an hour or two,
while she babbled nonsense, or wept.

Now she sits alone with a hired companion
and doesn't know who he is.
He is an old man who stumbles and falls

at each curbstone, and I am helplessly left
with my warehouse of words
not to violate the kinder refuge of silence.

Tears in the eyes of a man
who looks for his grave
at each crossing, but each time he tries

to tumble down into the earth,
he is knocked back onto his feet
by the hard compassion of pavement.

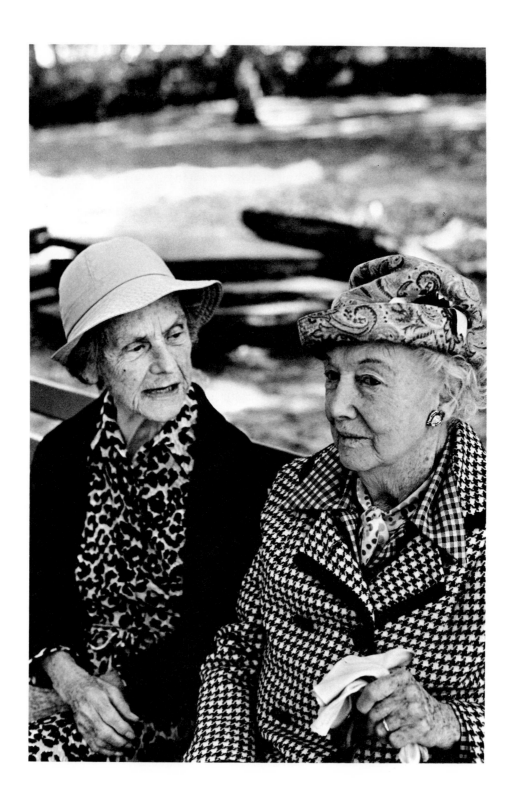

THE OLD WOMEN

One after another they come to me and report each other,
and every complaint about another person's greed or insensitivity,
every newly discovered fault, every case of insulting
behavior at the dinner table only seems to make them happier.

Each one seems to take pride in her low opinion of humankind,
as if this proved she had looked into the black Medusa-face
of reality and survived, without being turned to stone.
In the end, I turn out to be another case of human stupidity,

and they go away complaining about my intolerable tolerance
of a petty theft of a leftover piece of chicken.
No matter that the thief is old and hungry and poor.
I'm obviously a weak-minded man who lets other people take

advantage of him. But how stubbornly I persevere
in my weakness! I don't know why
they continue bothering with me, but somehow
they always come back, convinced that I know something.

What do I know? Odd things happen when they talk.
Their shoulders fly up to their earlobes,
as if a long-armed adversary had reached down
from the clouds and grabbed them under the armpits.

Their voices jump out of their throats and crouch
in their noses, somewhere between a whine and a battle cry.
I also hear an ominous clicking that I don't know how they produce.
And where do they get those little tropical oceans

in which they lower their eyes and set them adrift,
like rubber lifeboats? Somehow, in the face of all this
tossing about, they manage to stay in control
of their mouths, they remember to smile, their lips keep up

a constant mobilization of reasons. How well prepared
they are to beat down every objection, how well
they understand everything that has happened.
I have no idea what they're talking about.

Who pinched the right leg of the woman in the white knit dress?
How does the missing wristwatch fit into it?
Do they think I'm a police inspector or an examining
magistrate? Do they believe I've been gathering evidence?

If only they could see how harmless my files are!
Not one incriminating document! No transcripts or negatives!
Nothing but my passport and birth certificate,
a few old letters, some discarded poems, and my tax returns

for the last seven years. Sometimes, I'm seized
by the desire to grab them by the shoulders, shake them,
and explain my position: Look, you don't have to explain
anything to me, you must be mistaking me for another person,

someone who's been running around making vicious statements
about you. But they've already foreseen my abject denial,
and even before I've begun to speak, they hit me
in the chest with line after line of bullet-proof words:

how I try to frustrate them at every turn,
how my impatience, my refusal to listen,
the signs of my growing agitation
are proof of my intense dislike.

And I confess, in moments like this,
I, too, find other human beings insufferable,
and I can hardly tell the difference
between myself and them.

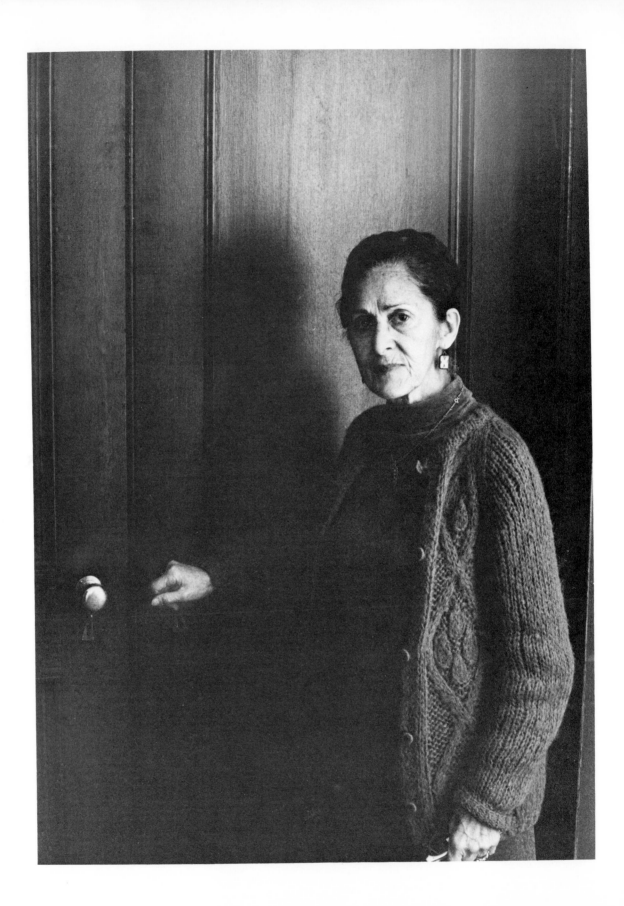

BUILDING THE WALL

I don't know how
many welcome mats
I've laid down for you
and for how long
but I find my doorway
is blocked with them now
and you can't come in.

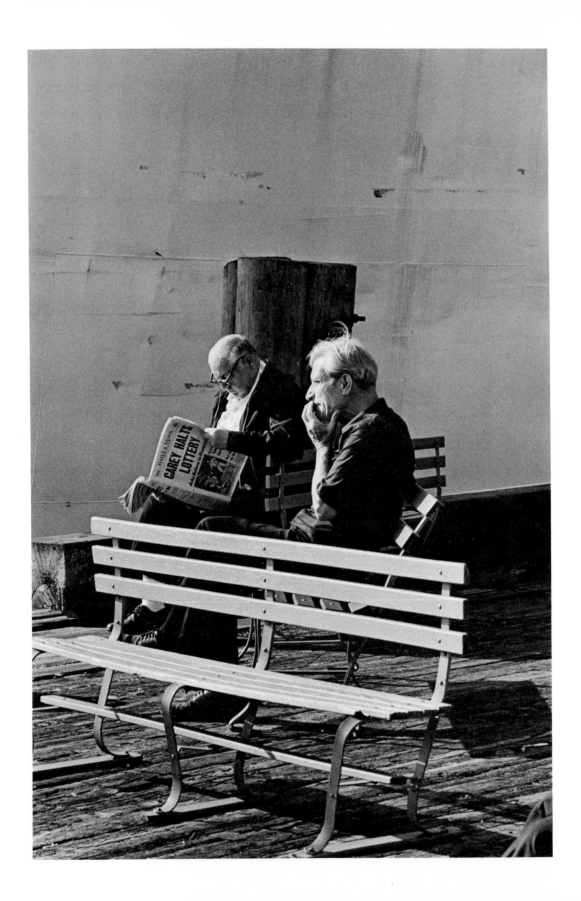

MY MOTHER'S SHOES
by Rayzel Zychlinska

At night my shoes look at me
with my mother's tired eyes,
the same look
of having gone through it all, and not arrived,
of having chased after luck, and missed it.
I go up into skyscrapers
and sink down in the valleys between them.
At night I come back
in my mother's shoes
bedecked with the patient dust of years.

Translated from the Yiddish

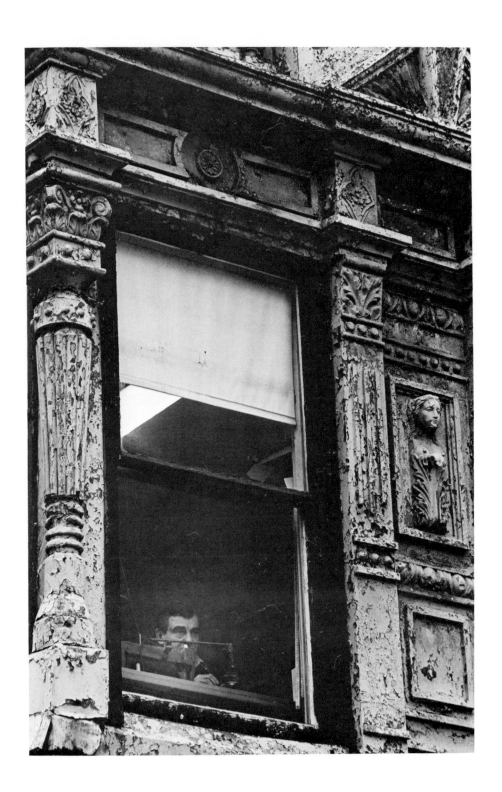

LOOKING INTO FIRST-FLOOR WINDOWS

1 Past five o'clock.
The old Chinese woman is ironing shirts.
Through the half-drawn curtain that separates
her work from her personal life,
I see a neat wooden table,
a refrigerator, and the edge of a cot.
Suddenly, I hate the loss
of all the hours that I, too, must stoop
for a little room to stand up in.

2 And sometimes, on my way home from work,
I see the bald head of a clerk
in a caged window.
He's hooked up to a hotel switchboard
by the earphones. All day long,
I connect elderly clients to the men
who will fix their pacemakers
and the women who will empty their bedpans.
Black wires coil around me.
Demands pass through me, on their way
to a little gratification. At night,
I feel the flesh shriveling on my bones.

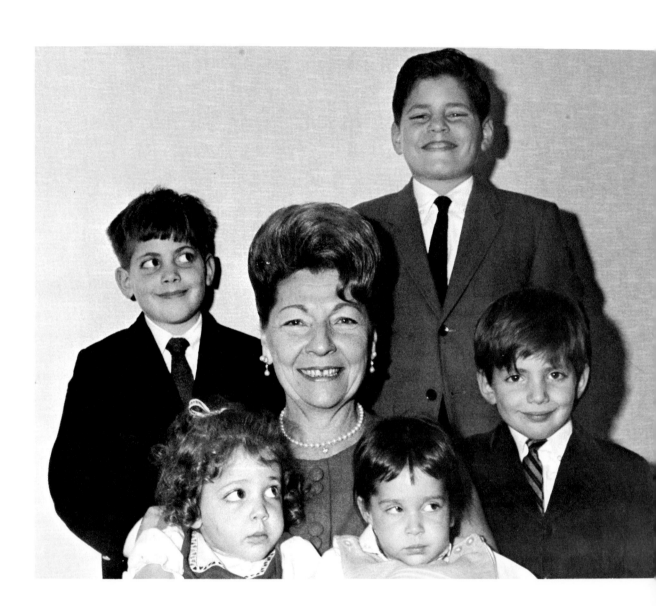

FAMILY CIRCUS

There's the night table
and the ledge of the bathtub
where you look many times
for the glasses that aren't there

and the streetcorner you come back to
in disbelief,
still expecting to find the drugstore
you dreamed onto it last night

and there's the family
you keep inviting to dinner.
The brother writes you a letter
as from a corporate giant:

"Owing to a previous engagement
which I was still unaware of
when we spoke last week, I will not
be able to attend your Passover meal."

The sister walks in an hour late
with the salad greens
in time for the chicken
to have long since fallen off the bones.

There's hardly anything left
to chew, it looks like a porridge
in which soup bones have been dumped
by an unseen hand.

And the mother has brought along
a long-lost Venezuelan cousin,
a future chain-store magnate
who's pleasantly depressed and smiles on cue.

As she shows him around, she repeats
he's both family-oriented
and a graduate fellow at Columbia.
To him she interprets the evening's events

like Howard Cosell giving the averages
of each player as he steps up to bat.
The father, meanwhile, between renditions
of Mozart's arias, interviews you.

And you are meant to offer up the vital
statistics of your accomplishment
like a horse that does sums,
clopping its foreleg under the big tent.

We must give the credit, of course,
to the trainer of this wonderful horse.
And thanks to the foreign guest,
everyone keeps up the goodwill performance.

For without the necessary stranger,
how could the family go on celebrating
itself, and prevent the unseen hand
from becoming a fist and pounding the table?

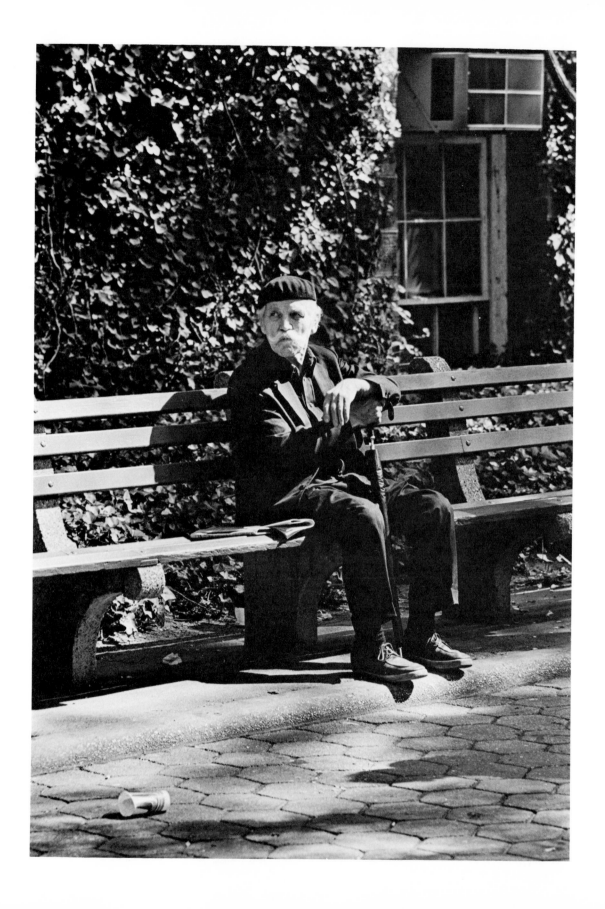

THE PERSISTING RAGE

1 Two fat notebooks of poems
 that never resolved
 themselves. Ten years of work.
 An extraordinary insomnia.

 The rooftops of Zurich
 and other detrusions
 of memory appear
 without reason, evoke

 an endless nostalgia and
 fade out. If only
 I could make them stand
 and deliver

 what would they tell me?
 That I witnessed those things
 and forgot
 I was ever there

 amazes me with the extent
 of loss. Awake
 nearly every night for the last week,
 and the days lost to me

 the last days of December,
 it's nearly 1978.
 I get up at 3 P.M., do
 small chores, avoid conversation.

 I'm fatigued until well
 past nightfall, then I turn
 back to the unfinished
 pages, trying to find something

 to salvage

2 Here's a long *cri de coeur* that I couldn't manage,
a fantastic chronicle, lumpy with the actual grief

of the days of December 1968, when my brother stormed
into my house, a greatcoat thrown over his shoulders,

like a general inspecting a captured city,
poked about in my dresser drawers, threw down

the coat, ripped a royal-red comforter from my bed,
bemantled himself, ordered a cup of tea, and

comfortably seated, recited a tale of ordeals
and conquests. How he pitied me!

He leaped up, tore off his clothes, began
to dance naked around me, singing,

You ripped off my brain waves! demolished my genius!
But I survived even you! Now you'll have to pay!

Moments later, the terrible performance done,
he was gone, and I left with the loss of a brother.

3 Now I meet him in strange places:
near the old synagogue on the Tiber,
in a street by de Chirico,

I call to him: I see where
you're hiding,
but the wall of the Roman ghetto

which cast that shadow here
was torn down ages ago.
Childhood's over. Come away

from the ancient city where you were less
than favored. Or in the Bronx,
in the live poultry market on Bathgate Avenue,

I cry: Where have ten years of appeasement
gotten me? You think
I'm going to put up with your abuse forever?

But he can't hear a thing, having taken
a fixed position behind the crates
which are stacked high between us,

a wall of cackling and chickenshit
gives whatever I have to say
an air of unreality.

Or in the Port Authority Bus Terminal,
he faces me
with a fat briefcase in each hand.

They're crammed with the evidence,
reams of torts and Talmudic reasoning,
histories of glances, innuendos, phrases

in which he demonstrates the existence
of a well-crafted malice, complete
with a book-length index to the whole affair.

From a distance, he appears to be
a portly Besarabian rabbi in a winter coat,
he's all buttoned up and out of place

among the streams of summery commuters.
He alone is immobile, weighted down
by baggage he won't let go of.

I approach, but the apparition
fails to become an ordinary person:
it is and is not my brother

who refuses to greet me. He's aloof
as a Hasid, silently repeating
the words of an interminable text

to ward off contamination.
As always in these situations, I'm anxious
and begin to gesticulate.

But the Hasid still doesn't recognize me.
Soon I'm pleading:
Look! It's me, Marc, your brother!

Remember the sharks we fought off
from the front porch in Kew Gardens Hills.
Remember the sheets we propped up

with a broomstick on Sunday mornings
before Papa got up!
We were Arabs together! We roamed the desert!

We shared an oasis! We survived
forty nights on the same life raft!
At least I've gotten his attention.

He looks at me with curiosity,
with amusement, then with contempt—
a quick shake of the head "No,"

nearly invisible but decisive,
as if he were getting rid of a wino or a whore
or a new convert selling peace of mind.

And so the tears come and I'm helpless
before them—
my fists knocking at his chest,

while he stands there, growing
larger and more rigid,
as he looks down at the spectacle

in a robe of magesterial dispassion,
like the monumental Balzac by Rodin.
He's taken my clamoring as proof of my guilt.

And I know it's too late.
Never again
will I try to get through to him.

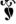

AMONG THE AMERICANS

They're born and they walk around
for a while, pretending
there's a path and they're on it.

Mostly, they're avoiding waterline
breaks, obsolescence, the latest
freed niggers. They follow

where the road is easiest, and oh
how they want, and what
they want so furiously

strikes me as crazier each day.
Letters of recommendation, a few good things
to be remembered by, new movies. . . .

And if there's sufficient leg room,
air conditioning, plush
seats to sink into, they're happy.

Not for long. Back on the street
they rub their eyes, the afternoon
hands them urgencies, drab assignments,

and off they go, making the rounds,
collecting items
for future use in their obituaries.

A desperate people, dressing
their dead
as if for a wedding,

begetting their mummies,
their babies
with lobster-pink skins

and dark prunes of immortal
germ plasm,
spawning perennial dreams

of the good life, distinguishing
themselves from their fellows,
throwing up

bridges into the empty sky,
great cathedrals
whose central doors will be opened

only to let them be carried out
feet first! Crazy
accomplishers,

they arm themselves with elaborate
branding irons,
trying to leave a mark

on the running water
and impress themselves
on the wind.

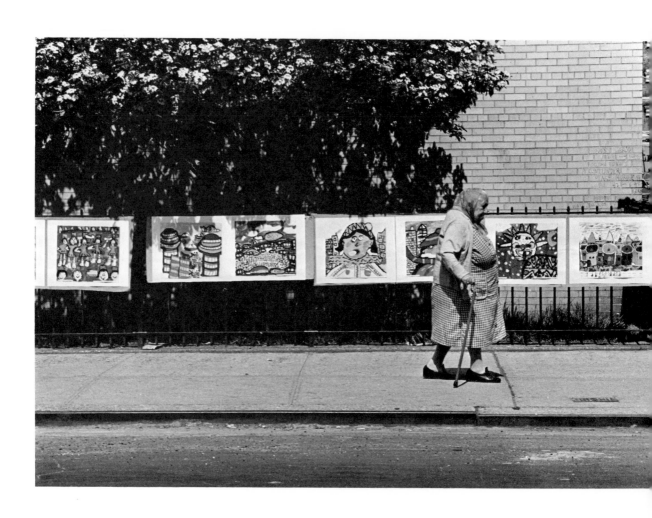

FINDING MYSELF
IN THE PRESENCE OF THE QUEEN

Two steps out of the subway
and rushing past the nuisance
of the blind pencil vendor,
I'm about to cross
into my formula for Thursdays:

Two hours for counseling and referral,
one for the lunch program,
three for leading the small discussions,
one for filling in the government forms,
and finally one for preventing
the angrier old men
from overturning the card tables.

I move towards responsibilities
like a samurai towards a host of foes—
and a scared pigeon flies up
a foot away from my face.

Startled, I lift my eyes and notice
what I've nearly missed
in the greengrocer's window:
a pineapple is now holding court
on top of a massive bed of asparagus.

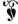

INSOMNIA

for Robert Glauboch

You often forgot
that you were a stranger
there in that daylight
office: old men
knocked timidly at your door,
old women came
from afar, from childhood
depressions in Galicia,
for a chance to consult you,
and young men, those elephants,
lumbered patiently
in the circles you preordained
for their labor.
In sum, budget lines
depended upon your eraser.

And so you sat
for three years, lifting
a little cathedral
of fingertips
to your mouth
while you leaned back
in a black leather chair
to listen.

You had the power
to make others ashamed
of their need
of you, but you heard out
their stories of hurt
pride and their losses
with such restraint,
you helped them approve
of what they had been
and were
and soothed no one
more than yourself.

In your navy-blue suit
with brass buttons
you forgot the sudden cry
of the sparrows
in the first light, announcing
the night was over
and you had lost
yet another round
in the venture to live
beyond human time,
among perfect images
of ordinary
losses which continue to work
in you, to excite
a horror
which makes you gasp for breath,
throw back the blanket
violently and run
to the desk
where you keep your vigil.

By the moment one's life is passing
and one day one will be no one.

For three years a little power
over the lives of others
helped you forget
the rage and despair
which have estranged you
from any establishment
and you slept
more or less soundly.

That time is over.

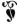

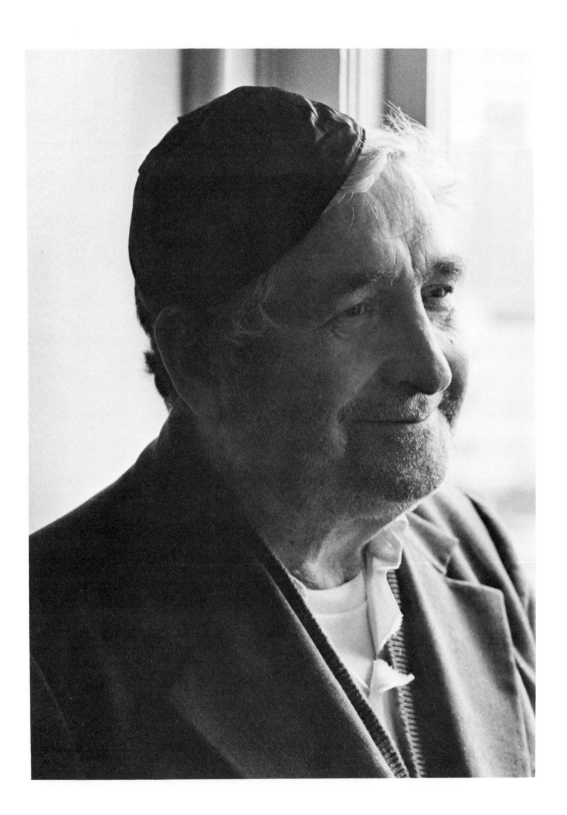

SONG

By my night shifts of smoking,
I dissolved the solids of health
and became receptive:
my father's heart attack came home to me.

By my insomniac vigilance,
I was kept awake by reports
of the exploding year 1914:
my grandfather's war passed into my body.

By my fatigue, my loss of control
and green candle, I thawed my tongue,
and out ran the pricking
world of reawakened sensation.

By my song, with its prehensile iambs,
I lay hold of a banister
on the edge
of our common suffering.

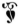

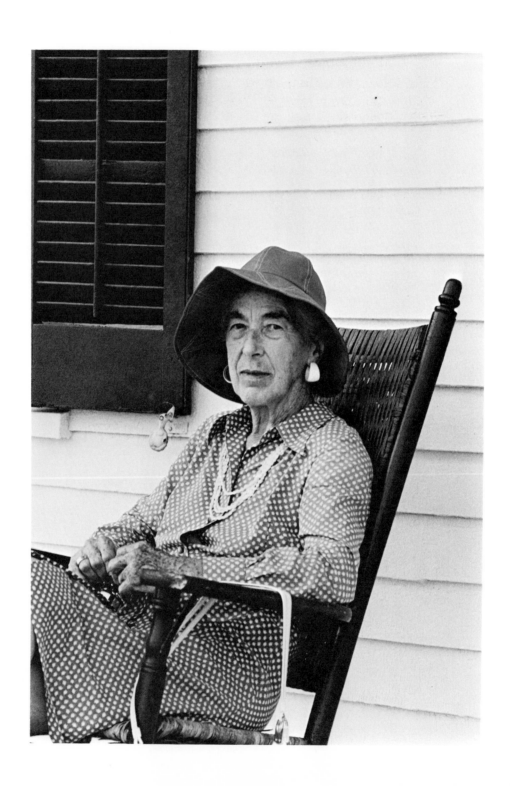

HUNGRY GHOST

How often I've come along
with just what was needed—

an envelope, a mirror, a little
volume of Buddhist
teachings, a ring
of keys that opens all kinds of doors

a snack of almonds
and raisins, a bottle
of correction fluid, a tourniquet
a rain hat

What haven't I pulled
out of the shapeless pouch
that I carry
the way a peddler carries his pack
The appendage
is so involved in the shadow
I cast
that without it
I can't tell who I am

And how often I amaze
even myself
reaching into this bag
with its seven compartments
and fishing out Lord knows what
remedies!
 It's fantastic
when I come up with
some newly recovered object
I swell with love
for everyone that I help
I pat each
of them gently on the back
or touch their forearms
I'm completely at ease

A moment later, and the salt tears
start into my eyes
as I realize
once again
what a world of forgotten things
I walk around with—

a pea-jacket button from a coat
long gone, a bag of rose-hips
tea from a previous marriage
an ivory back scratcher
from my father's nights of insomnia
on how many cots and sofas
in the '30's, a long string
of my grandfather's worry beads

And today I found a fat red
rubber band
for a scholar whose disordered
pack of 3-by-5 cards
will never be shuffled
into important work
and I squeezed a shot of cream
out of a wrinkled tube of skin
salve
for a woman whose hands are cracking

Despite this, I don't know
what to do for myself
For myself I have no
supplies, no tricks, no herbal
medicines, nothing
to lift
the melancholy
that drags down my shoulders

I feel like a cloud
being carried off
from the substantial person I've been
before—

the one whose tongue was busy
with love
who's repelled
by the dumb thing I become
in the whirlwind of good works

or the one
whose attention to words and music
is dispersed
by a long pair of uncrossed legs
(the rubbing of nylon against nylon
like a needle, scratching out
the oratorio in my head)

or the one going around in circles
on a picket line
yearning for the days of solitude
and study
when I acquired a foreign tongue

And so I live
among these departing ones
I rush
from one to the next, trying
to be true to each one
in turn, and true
to the total figure they make
when they're made
to stand on each other's shoulders
and be ten-armed and abstract
and monolithic
like a totem pole of acrobats

But this
to contain the whole population
of my passing
selves
leaves me weightless
among unrealities

I ask: why this
hunger
to comprehend everything
that I am? Why can't I
let myself go
from change
to change
without knowing what lies
at the heart of it?

There is nothing I can do
to end this obsession

It runs its course, bearing me
into the late hours
of despair
when I'm nothing but a free-floating mass
of evaporated tears, aching
to be weighed down
by the familiar burden I carry

And so I resign myself once again
and turn with relief
to the small business I carry on
among people

I put on my peddler's pack
and deal myself out
in bits and pieces.

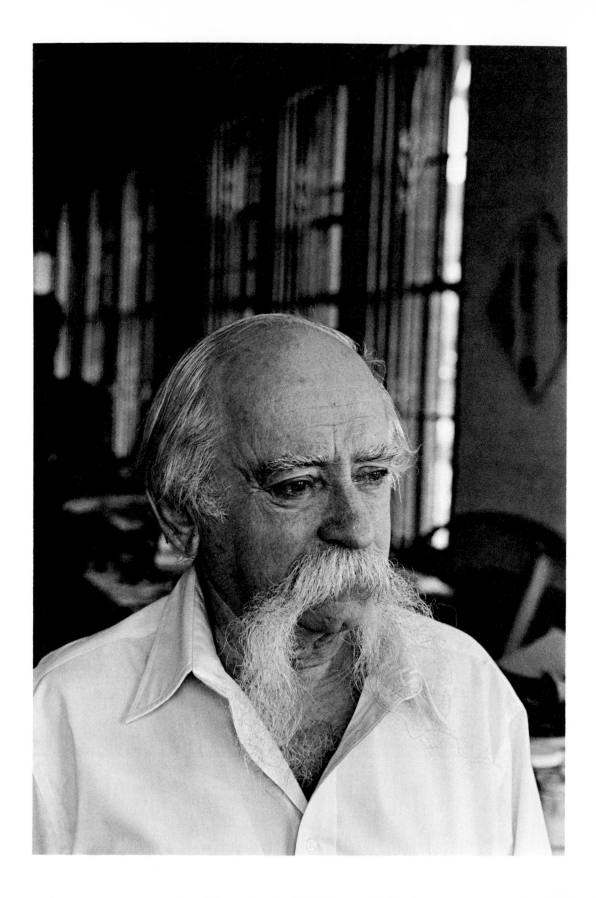

A MAN AT WORK

A man stands in his room, dreaming,
among his books.
The day grows quiet, and quieter.
Outside, it is Inwood and Sunday.
It is a quietness in which the Irishry
go to church and the Jews
buy the *Times* and bagels for breakfast.
It is a white neighborhood.
He loves to be a stranger here.

The rusty year has finally managed
to be January
and leaves a large envelope
of sky at his window.
He dreams of nothing
but the quietness that has come
to the streets, and the quietness
has come to him at last.

He stands over the busy squares
and white lanes of the rug
as if the rug were the city
and he were Piet Mondrian
looking out, high over Broadway.

The light turns green, a wedding
caravan turns the corner, honking
for joy. How goose-like
we are in our exaltations!
The factory in the chest
hammers and whistles:
once in a great while
a man dreams he is going to make peace
with his life.

GLOSSARY

"Underground":
> *Zhid* (Disparaging Slavic term)—Jew
> *Nagaikas* (Russian)—whips

"Erev Shabbos":
> *Yohrzeit*—anniversary of a death

"Medium":
> *Kapoteh*—kaftan, long gabardine coat worn by observant Jews
> *Tish mit mentshn*—literally, "table with people"
> *Nign*—melody

"Pig Market":
> *Agunah*—deserted wife

"Many Ghettos":
> *Treyf*—impure, contrary to the dietary laws

"Golus Jews":
> *Golus Jews*—literally, diaspora or exile Jews: "When we
> youngsters wanted to insult one another, we could find no
> more humiliating appellation than *golus-Jew*. I remember
> clearly how one day one of our Gentile friends heard us use
> this term and asked to have it explained to him. One of us
> gave him a literal translation which proved entirely inade-
> quate. He was told that *golus-Jew* meant a Jew in exile, and
> he could not understand why this term should carry any
> opprobrium."—Hayim Greenberg, "Golus-Jew," *Voices from
> the Yiddish* (University of Michigan Press, 1972).
> *Tsitses*—tassels on the undergarment worn by Orthodox Jews

"Dancing":
> *Kvelt*—glowed with pride

A NOTE ON THE POET

Marc Kaminsky was born in New York City in 1943 and earned graduate degrees at Columbia University and the Hunter College School of Social Work. He taught literature and creative writing at Hunter College, in the CUNY English as a Second Language program in Williamsburgh, and in a storefront academy in East Harlem. He served as director of the West Side Senior Center, run by the Jewish Association for Services for the Aged; and he founded and directed the Artists & Elders Project, while working at the Teachers & Writers Collaborative. He is presently co-director of the Institute on Humanities, Arts, and Aging of the Brookdale Center on Aging of Hunter College.

He has published three collections of poems, including *A Table with People* in 1982 (Sun Press), and his stories and poems have been widely published in journals. His articles have appeared in varied publications, including *The American Scholar, Midstream, Sing Out,* and the *Journal of Gerontological Social Work.* His theater pieces have been produced by the Judson Poets Theater and the Theater for the New City, and he is the author of *What's Inside You It Shines Out Of You* (1974) and editor of *All That Our Eyes Have Witnessed,* both published by Horizon Press.

A NOTE ON THE PHOTOGRAPHER

Leon Supraner is a native New Yorker and a self-taught photographer. Best known for his "exquisite black and white geometrical *drawings*" and for the Constructivist quality of his architectural prints, he received recognition for his photographic essay on senior citizen centers and the aged. His work is in the permanent collections of the Museum of the City of New York and the New York Historical Society. His photographs have been widely exhibited, including a one-man show at the South Street Seaport Museum, and group shows at the Parrish Art Museum, the Heckscher Museum, and the New York State Museum. A graduate of Long Island University, he pursued an interest in English literature at New York University graduate school. At present he resides in Roslyn Harbor with his wife, Robyn, a children's book author and poet, and a constantly changing assortment of their four children.

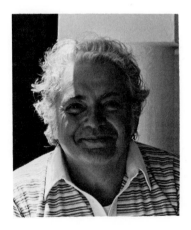

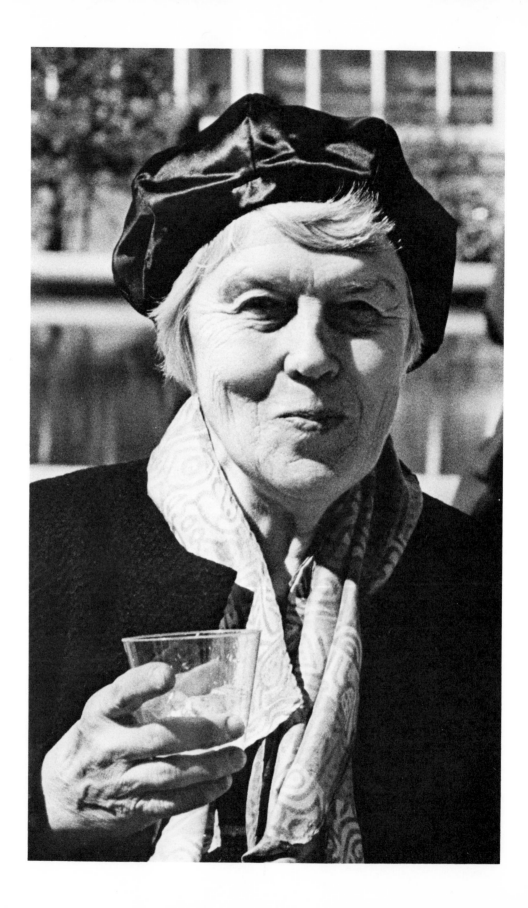